1225

The Art of
THE POLAR EXPRESS

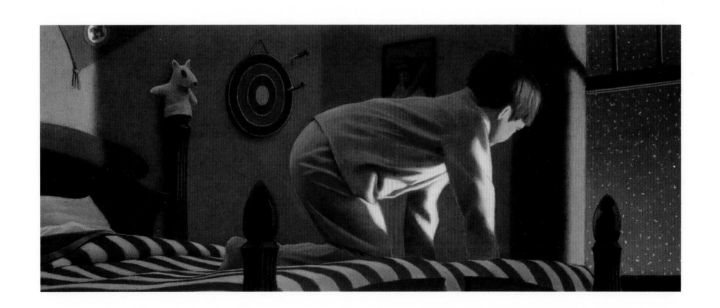

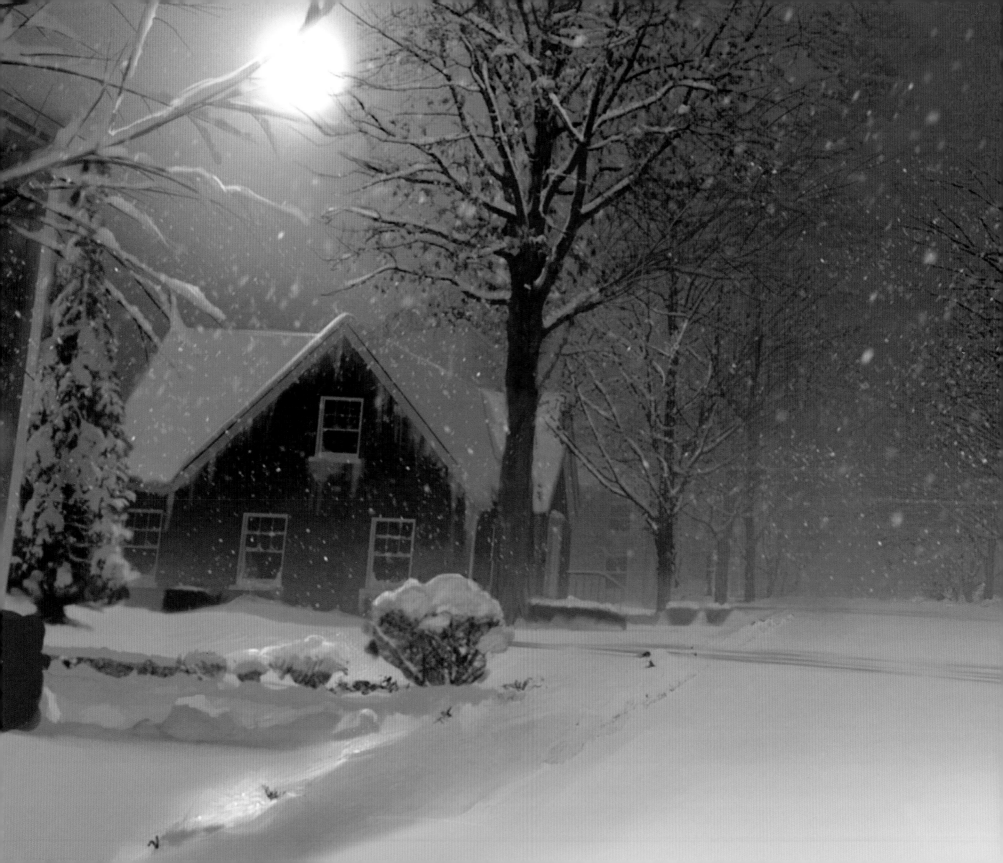

The Art of
THE POLAR EXPRESS

by Mark Cotta Vaz and Steve Starkey | Introduction by Robert Zemeckis

CHRONICLE BOOKS

SAN FRANCISCO

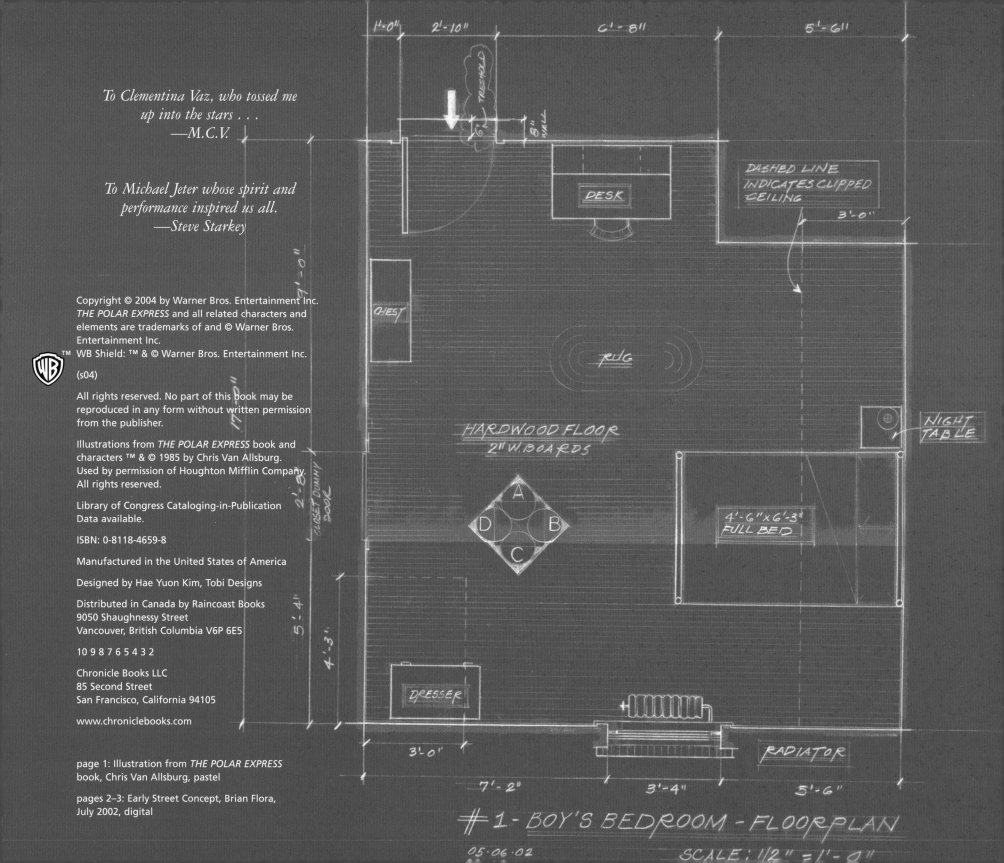

*To Clementina Vaz, who tossed me
up into the stars . . .*
—M.C.V.

*To Michael Jeter whose spirit and
performance inspired us all.*
—Steve Starkey

Library of Congress Cataloging-in-Publication
Data available.

ISBN: 0-8118-4659-8

Manufactured in the United States of America

Designed by Hae Yuon Kim, Tobi Designs

Distributed in Canada by Raincoast Books
9050 Shaughnessy Street
Vancouver, British Columbia V6P 6E5

10 9 8 7 6 5 4 3 2

Chronicle Books LLC
85 Second Street
San Francisco, California 94105

www.chroniclebooks.com

page 1: Illustration from *THE POLAR EXPRESS*
book, Chris Van Allsburg, pastel

pages 2–3: Early Street Concept, Brian Flora,
July 2002, digital

Acknowledgments

Art teams for The Polar Express

Northern California

Doug Chiang	Young Duk Cho
Aaron Becker	Matthew A. Ward
Brian Flora	Zac Wollons
Marc Gabbana	John Goodson
Randy Gaul	R. Kim Smith
Kurt Kaufman	Erin Collins
Bill Mather	Josh Viers
David Saccheri	Joey Spiotto
Mark Sullivan	Roel Banzon Robles
Pete Billington	

Southern California

Rick Carter	Scott Herbertson
Simon Wells	Jackson Bishop
James Clyne	John P. Goldsmith
Stefan Dechant	John Villarino
Phillip Keller	Jeff Beck
Alicia Maccarone	Cathlyn Marshall
Norm Newberry	Smokey Stover
Tony Fanning	Kenneth A. Larson
Karen O'Hara	Jeff Frost
Robin Miller	Dean Wolcott
James Hegedus	Tony Bohorquez
Oliver Scholl	Todd Cherniawsky
Andrew L. Jones	Diana Goodwin
Jim Wallis	Maureen Beatty
Mike Stassi	Ryan Cosgrove

Costume Design for The Polar Express

Joanna Johnston	Robin Richesson
Pam Wise	Diana Wilson

With much appreciation: Tamara Johnston at ImageMovers, Erin Collins at Doug Chiang's department, and Michelle Minyon at Sony Pictures Imageworks.

—M.C.V.

All of the people who contributed to creating the art contained in this book owe their initial inspiration to Chris Van Allsburg, the author and illustrator of the original book. The feelings in the book are truly universal.

Bob Zemeckis, Jack Rapke, and I are deeply indebted to Tom Hanks and Gary Goetzman at Playtone, who trusted us with not only the vision of The Polar Express, but the movie.

Not every movie has the support and passion from a studio that we had on The Polar Express. We were all so fortunate to have Alan Horn at Warner Bros. and Martin Shafer at Castle Rock love this film as much as we did. And to Steve Bing for his limitless energy and enthusiasm. Thank you.

Chronicle Books—this entire undertaking would not have been possible without you. I know it was the most difficult delivery schedule you have ever faced, and you not only made it, but met my highest expectations.

Once The Polar Express left the station, Bob Zemeckis was the conductor on the journey. Week by week, he surprised us and touched us with his ever-expanding story, and gave us the courage to believe in our imaginations; we all thank you.

Tom Hanks gave heart and soul to so many characters and so many of us while making this film. He led the other actors—Nona Gaye, Eddie Deezen, Peter Scolari, Michael Jeter, and all—down a new road where the digital age met black-box theater. All we could do was watch with awe and wonder.

I owe a special thanks to Rick Carter and Doug Chiang who co-designed the most beautiful paintings on film and to the other artists who surrounded Bob during our roundtable meetings while he was writing the screenplay: Simon Wells, Stefan de Chant, Phil Keller, and James Clyne. All of you formed a perfect creative circle for Bob Z by allowing him to see his movie for the first time.

I would also like to thank Bill Broyles, who has journeyed with Bob Z and I from the South Pacific to the North Pole. Your collaboration makes everything right.

Following close behind our initial circle of artists were all those in the art departments in Los Angeles and San Francisco, who designed the movie not only to live in the digital world, but in the so-called real world of our performance-capture sets.

Sony Pictures Imageworks has so many creative personnel—where do you start? Ken Ralston and Jerome Chen. They are the best, and they assembled a group of professionals who are unequaled. A special thanks to Vlad Todorov for his countless real and whimsical character designs. And thank you to Debbie Denise for watching over the asylum.

Starting from designs she created in London, our longtime collaborator Joanna Johnston designed the perfect costumes for all our characters, which were beautifully illustrated by Robin Richesson. Santa has never looked so good.

The film's producers all helped me every day on this film. First and foremost, my partner at ImageMovers and longtime friend Jack Rapke, as well as Gary Goetzman and Bill Teitler.

Everyone has those around them who really are responsible for sharing in all of their work. In my case, this was my co-producer Steve Boyd and my assistants Heather Smith and Tamara Johnston. I thank you so much for your spirit and dedication.

Finally, I must thank my wife, Olivia, who when I told her about the book said, "That, and the movie, too?" Her love and support makes it all worth it.

—Steve Starkey

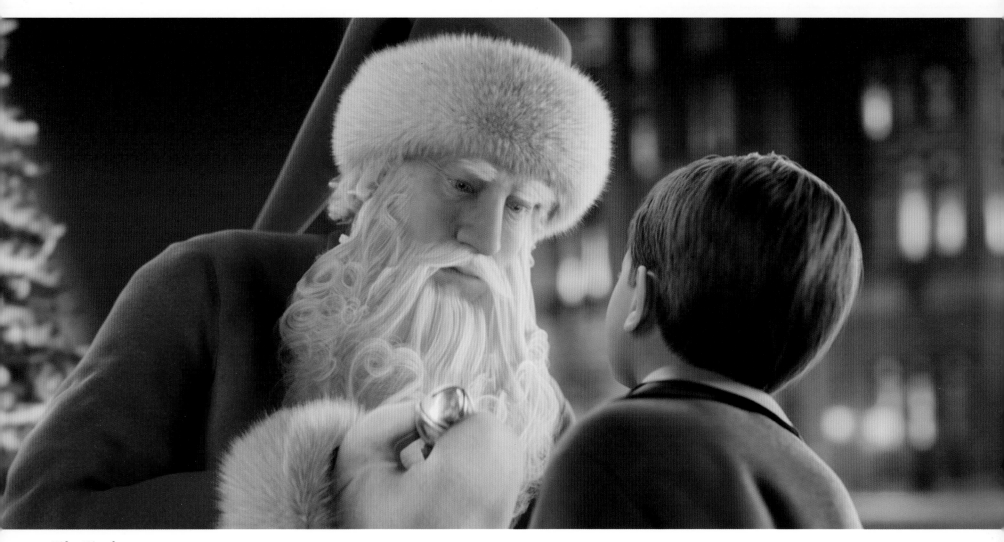

Film Final
Sony Pictures Imageworks

Introduction

hen I was a kid, I could never fall asleep on Christmas Eve. I'd lie awake, tossing and turning, my mind filled with questions: Is Santa really coming? How does he know where I live? We don't have a fireplace—if he slides down our chimney, will he end up in the furnace? I guess you could say I was a skeptic; but despite my doubts, Christmas was always a magical time for me.

After first reading Chris Van Allsburg's *The Polar Express* in 1985, I immediately connected to the story's sense of childlike wonder. It became an annual tradition to read the story to my son while he was growing up, and it never failed to fascinate him. The imagery possesses an otherworldly quality, existing somewhere between dreams and reality, which captures the mystery of a restless Christmas Eve.

In order to accurately translate Van Allsburg's enchanting vision into a feature-length film, I called upon my longtime collaborators—production designers Rick Carter and Doug Chiang, and visual effects supervisor Ken Ralston—to help develop the look of the film and illustrate the world I was imagining.

The writing process was unique because I was able to brainstorm, imagine scenarios, and expand the story to new levels with my team of artists. Seeing the film come to life simultaneously while writing was an inspiration, and the artwork proved to be an invaluable resource.

This is where the journey truly began.

—Robert Zemeckis

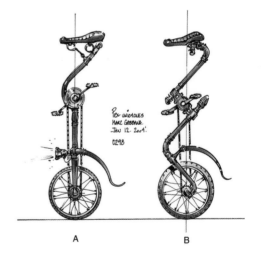

A B

Unicycle Designs
Marc Gabbana, January 2004
pen and marker

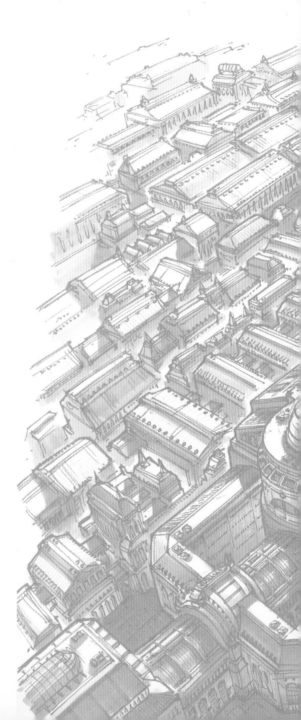

 hristmas. It's a word planted like a seed in the human heart that bursts forth in its season and is rooted in the deepest human longings and hopes for the future. For many, its spirit is conjured up in the iconic and very merry form of Santa Claus, the jolly old elf with the snowy white beard and bright red suit who's rumored to live at the top of the world. The legend goes that elves inhabiting the North Pole make the toys that Santa brings to all good children the night before Christmas, making his deliveries from a sleigh drawn by flying reindeer.

Santa Claus can be a child's first mystery—does he exist or doesn't he? The answer to that question has often marked the passage from childhood innocence to acceptance of pragmatic, mundane realities. This childhood conflict is the theme of *The Polar Express,* the beloved 1985 children's classic written and illustrated by Chris Van Allsburg, whose words and pastel paintings tug at the imagination like a wondering child pulling at a parent's hand.

In Van Allsburg's fable, the narrative voice, years removed from boyhood days, recalls one special, long ago Christmas Eve when he lay awake in his bed, listening for Santa's sleigh bells. He hears instead the grinding metal and hissing steam of a train pulling to a stop in front of his house. A conductor ushers the pajama-clad boy aboard, where he finds other boys and girls who've all been similarly roused from their beds. They're spirited away through dark forests, up into moonlit mountains, down snow-covered plains, and across the polar ice cap until the boy sees in the distance, faintly and like a half-remembered dream, the twinkling, alien lights of Santa's North Pole.

Actor Tom Hanks, a veteran of such Robert Zemeckis productions as *Forrest Gump* and *Cast Away,* owned the rights to *The Polar Express* and brought it to the

When Bob decides to make a movie, you can feel it in his voice. I said to him, "I think this book bit you." He said, "Yeah, I think it has." Bob calls it a "white out"—he begins to focus completely on the movie and it takes over his mind.

—Steve Starkey

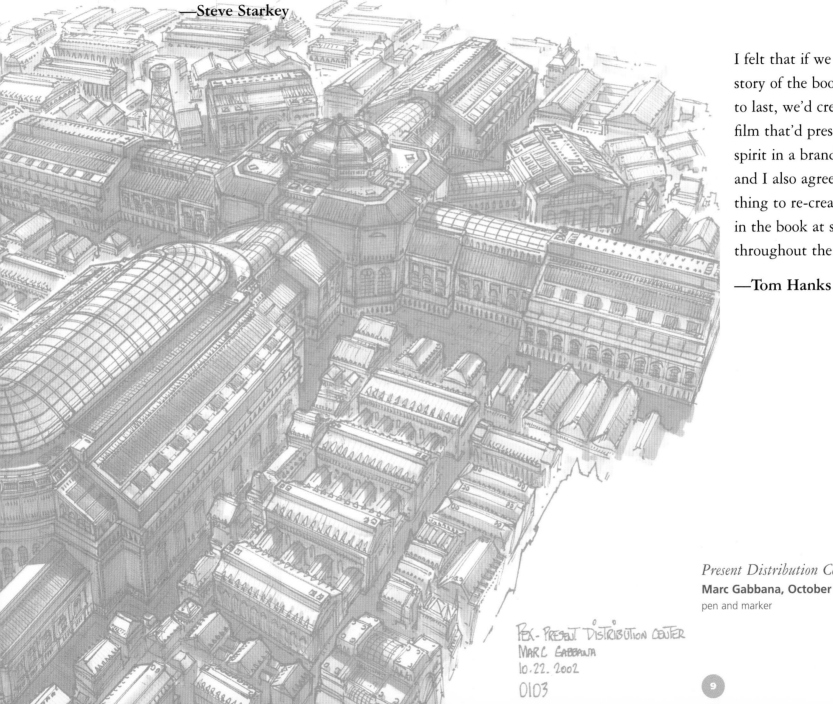

I felt that if we followed the story of the book from first line to last, we'd create an elegant film that'd present the Christmas spirit in a brand new way. Bob and I also agreed it'd be a pure thing to re-create each painting in the book at some point throughout the movie.

—Tom Hanks

Present Distribution Center
Marc Gabbana, October 2002
pen and marker

9

director's attention in the hopes Zemeckis would direct and that Hanks could play the conductor. It seemed perfect Zemeckis territory—many of his films, from *Back to the Future* to *Who Framed Roger Rabbit* and *Contact,* had visited strange worlds and along the way bent the old space-time continuum. But the director was uncertain about how to approach Van Allsburg's little book. How would he do it? What was the story about, really?

"Then things started to ferment in my mind and I realized the book was actually the perfect outline for a movie," Zemeckis recalled. "The story was very linear, very clear. Kids can take it literally as this journey to find Santa Claus, while older readers can understand it as a metaphor for much bigger ideas. It deals with symbols of Christmas but at its core is a universal story about belief in things you don't completely see or understand."

The filmmakers needed to expand upon Van Allsburg's Christmas story to make it meet the requirements for the length of a feature film. This was the first step in a creative journey that lasted two and a half years before *The Polar Express* pulled into theaters in the Christmas season of 2004. Joining Zemeckis and Hanks would be such production principals as producer Steve Starkey and production designer Rick Carter, both Zemeckis production veterans who'd been sharing adventures since their work together on Steven Spielberg's *Amazing Stories* television series in the 1980s. Costume designer Joanna Johnston, who'd worked on other Zemeckis productions including *Roger Rabbit* and *Cast Away,* got on the train. Carter and Starkey also brought aboard Doug Chiang, a former Industrial Light + Magic (ILM) creative director who'd of late been exploring the *Star Wars* universe as a design director on *The Phantom Menace* and *Attack of the Clones.*

Adaptations for feature length resulted in some changes to the structure of the original story; for example, the train arriving at precisely five minutes to midnight and the clock not striking twelve until, after many adventures, the Boy reaches the North Pole and Santa arrives. The filmmakers also significantly expanded on those

Every single scene in the book is represented in the movie.

—**Robert Zemeckis**

Snowman
**Bill Mather and
Marc Gabbana
April 2003**
digital

adventures, in the process introducing characters met aboard the Polar Express that are not in the book, including a girl, a know-it-all boy, and a lonely boy.

The creative team also found they needed to depart from the usual, well-traveled roads of their craft. Instead of first generating a screenplay to serve as the source, the book continued to provide the touchstone throughout production, as Zemeckis and company further developed the themes in a script and developed the strategies used to bring Van Allsburg's paintings to cinematic life. In a major redefining of how to make an animated film, the traditional separation of the preproduction phase of dreaming up the look of characters and environments and the postproduction stage of final images became virtually one streamlined process. A wealth of conceptual art accumulated as the artists explored potential looks for characters, costumes, and environments, and this art also served as templates for the final images. A selection of this vital, inspirational art is what fills the pages of this book.

The team knew from the beginning the fantastical story required a powerful dose of movie magic, and they got it in the digital realm, courtesy of the Sony Pictures Imageworks visual-effects company. Sony's senior visual-effects supervisors Ken Ralston and Jerome Chen coordinated, at peak, some 350 visual-effects artists who would ultimately conjure Van Allsburg's world with 3-D computer graphics (CG) character models animated in 3-D environments where the director has the freedom of a "virtual" camera. But while a typical animated film, whether hand-drawn or digitally created, uses actor's voices for characters, in *The Polar Express* each actor's *actual performance*—every body movement and facial expression— would be transferred to and integrated within the computer-generated characters. The process, known as *motion capture* (or *performance capture* as this production preferred to call it), allowed Tom Hanks to play the Boy hero (with his performance scaled to the character's size), the Boy's father, the Polar Express conductor, a ghostly hobo who rides the train, and Santa Claus himself.

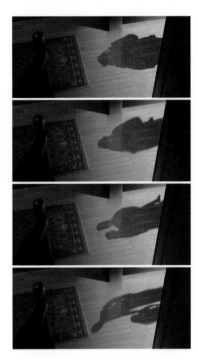

The Boy mistakes the combined shadows of his father and sister for Santa's.

Shadow of a Doubt
Aaron Becker, April 2003
digital

*Boy's Bedroom Set for
Performance-capture Test*
June 2002

In employing these innovations in methodology and technique, the filmmakers were striving to conjure up a common, magical reference point—the twilight state of mind between sleeping and awakening. In that dreamy world of feeling, as production designer Rick Carter noted, there are no roads and all clocks are set at five minutes to midnight.

In the opening passage of Chris Van Allsburg's *The Polar Express,* a nameless boy lies quietly in his bed on Christmas Eve, listening for and hoping to hear the jingling bells of Santa's sleigh, the sound a friend has said he will never hear because *there is no Santa Claus.* Van Allsburg's first pastel painting depicts the boy on the edge of his bed; he's been aroused by a strange sound and is staring out his window into the void of a snowy night, poised on the edge of belief and disbelief.

That boy's situation was familiar to the filmmakers. They were in the business of dreammaking and for them, like that hopeful boy, there was no other option— they *had* to believe in Santa Claus. If they didn't, how could they expect future audiences to suspend disbelief and join them on the Polar Express? "The whole movie business is about believing in something that's not tangible," chuckled producer Steve Starkey.

Starkey recalled that when Tom Hanks brought the book to Robert Zemeckis, the director first imagined *The Polar Express* as a silent movie. "That means Bob *saw* something, he didn't hear it," added production designer Rick Carter. "He then realized the idea of *hearing* was the sleigh bell from the story. The big moment of the movie would be about hearing the message, that belief in things that aren't tangible.

"The challenge was how to bring this book to life as a movie. Since the form of the movie ultimately involved performance capture and a computer-generated world, it forced Bob to redefine what he thinks about movies, and he invited us all on this cinematic journey of discovery with him. The whole production was a leap of faith from ideas that came out of the collaborative process."

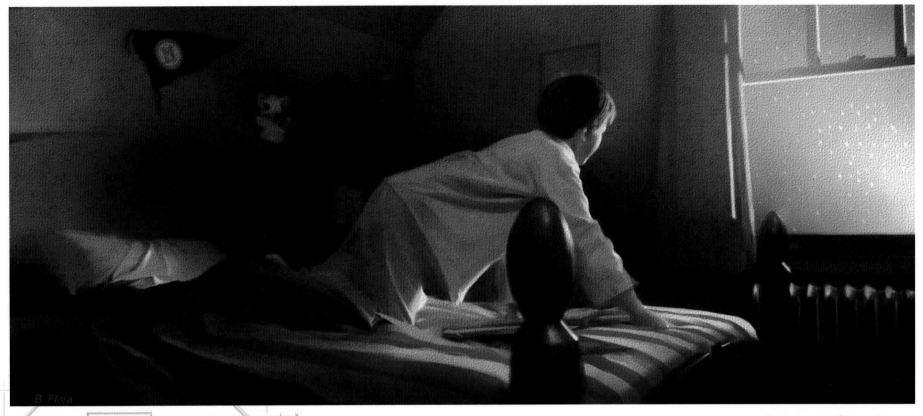

B. Flora

Bedroom Lighting Concept
Brian Flora, June 2002
digital

The starting point was the book with Chris Van Allsburg's paintings. Our character of the Boy was inspired from that first image in the book—he's sort of an "Every Boy of America." But we were going deeper into the environments than the book did. Take the book's first image—there's a bed, a window, part of a wall. But what does the rest of the room look like? Is there a stairwell? What does the rest of the house look like, the neighborhood, what do things look like when the train leaves town? Even if you start, as in this movie, with a touchstone, you have to explore the look of everything entirely.

—**Steve Starkey**

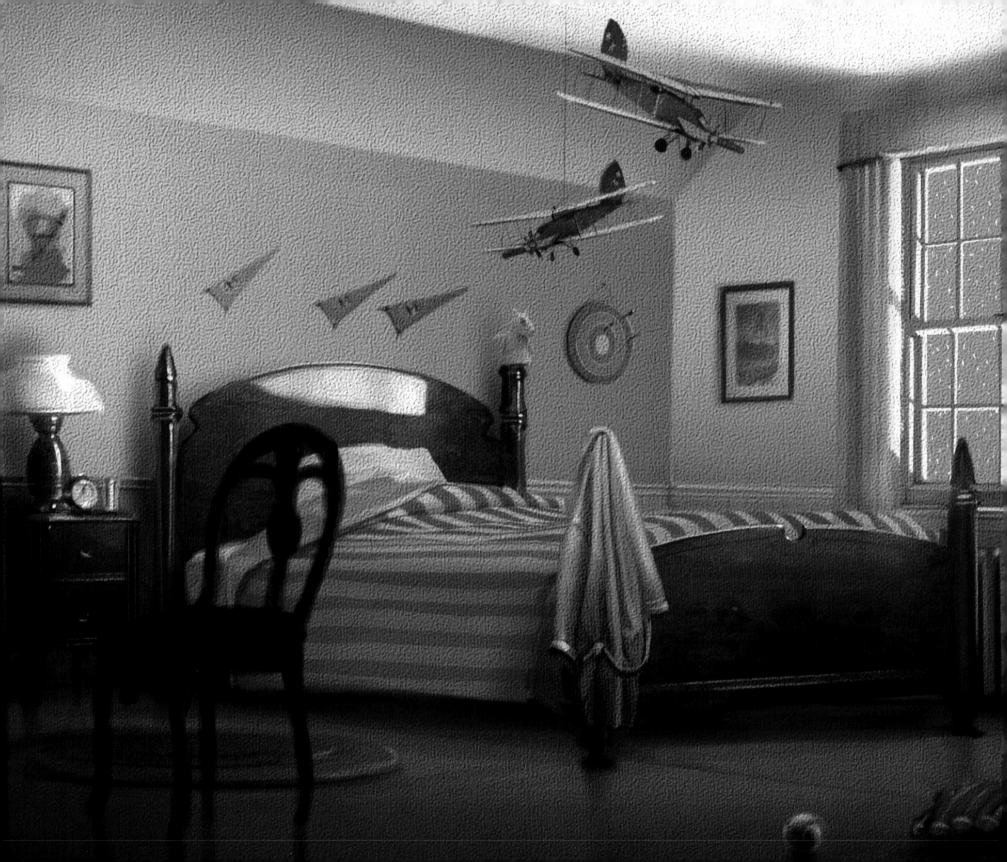

In the bookcase of the Boy's bedroom there's a set of the Hardy Boys adventure books that I used to read as a kid. There are Tinker Toys and other toys in the background that us baby boomers would remember.

—**Ken Ralston**

Preliminary Bedroom Development
Doug Chiang, March 2002
digital

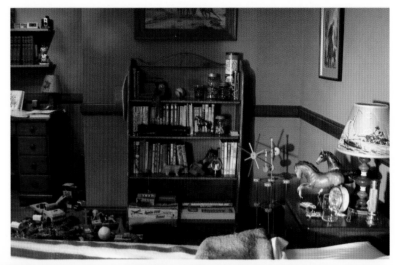

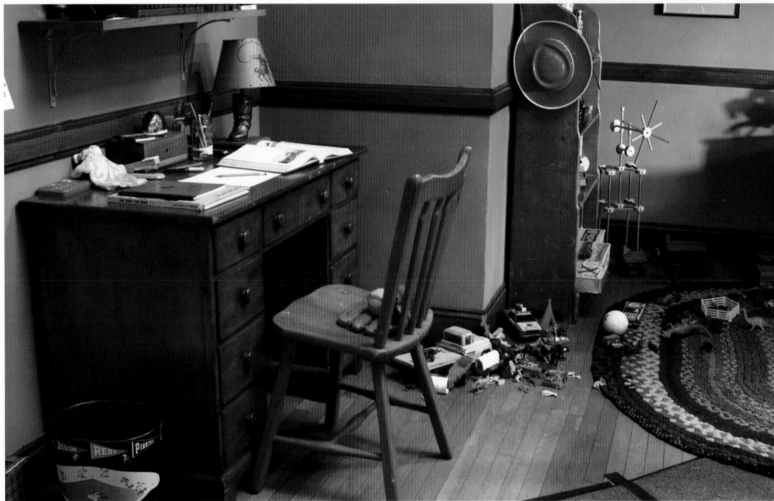

As the story opens, our hero Boy is having his first moments of doubt about Santa Claus. On Christmas Eve night he's looking down from his stairwell and sees what looks like the shadow of Santa Claus. But then he realizes it's just his father carrying his sister to bed. He hears his sister expressing doubts about Santa Claus and he himself wonders how the Santa myth can be true. Back in his room he looks at a book that describes the North Pole as stark, barren, devoid of life. There are all these things that fuel his crisis of doubt.

—Steve Starkey

Living Room
Marc Gabbana
April 2003
digital

Sister's Bedroom
Bill Mather, April 2003
digital

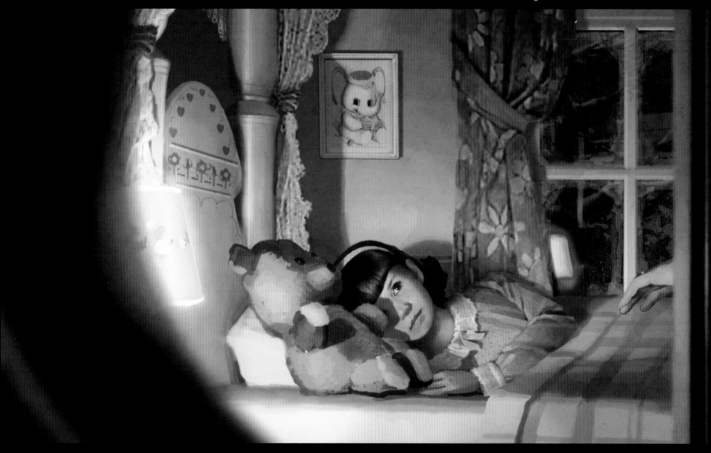

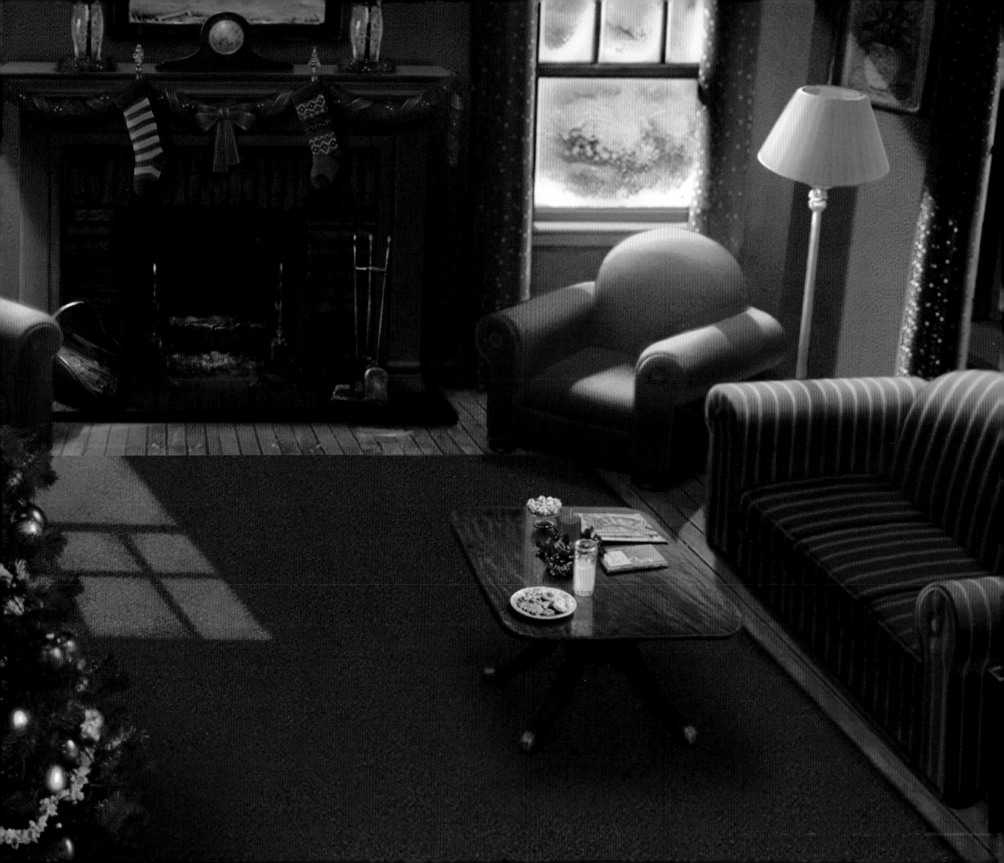

 t the first meetings held in Zemeckis's ImageMovers production office at Universal Studios, the director asked a roundtable of production principals their personal feelings about the book. They found themselves referencing *The Wizard of Oz* as an archetype, with Dorothy and her friends' odyssey along the Yellow Brick Road echoed in the magical train trip where the Boy and his new friends share a great adventure and each learns an important and personal lesson.

One creative approach was the decision to draw upon the boyhood memories of Chris Van Allsburg and Robert Zemeckis, both of whom had grown up in the Midwest. "Bob and I have a common reference point—the Beatles," Rick Carter noted. "In the case of this movie, I looked at it as the Lennon and McCartney song, 'In My Life'—a looking back."

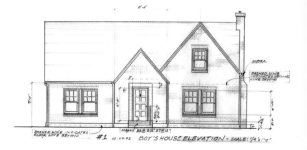

Architectural Drawing of Boy's House
Art Department, 2003

Boy's House
Marc Gabbana
April 2003
digital

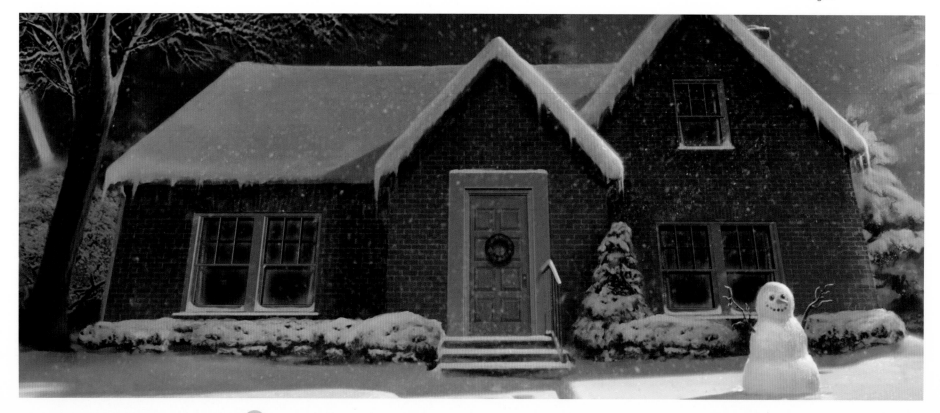

Robert Zemeckis said that at the beginning, the art department "went out in search of Chris Van Allsburg." The director had a hunch about what they'd find. "Sure enough," Zemeckis recalled, "the art department explained the very house where Chris Van Allsburg grew up in Grand Rapids, Michigan, was similar to the one depicted in the book. The Polar Express itself is also similar to the kind of electric train set that everybody who was a kid in the 1950s and early 1960s might have had under their Christmas tree. Even Van Allsburg's vision of an industrial North Pole recalled Detroit, which he'd have visited as a boy. The story was all resonating from a midwestern, Middle-American Christmas memory."

Zemeckis, who grew up in the 1950s on the South Side of Chicago, had the same midwestern roots and memories. Before production began on *The Polar Express,* the director had celebrated his fiftieth birthday with family and friends on a bus tour of his boyhood neighborhood, which struck a serendipitous spark in production designer Rick Carter and producer Steve Starkey. They decided to use both the author's and director's childhood haunts as inspiration. "We as filmmakers have all done movies where we reference aspects of our own lives, which we bring to a production and which personalizes it," Carter said. "To go to Chris's and Bob's old neighborhoods was just like in *The Wizard of Oz,* where it's all really happening in your own backyard."

Carter took a production research trip that began at Van Allsburg's boyhood home, arriving in time to see a pretty-as-a-postcard Christmas scene of the old neighborhood covered in a fresh snowfall. In the movie as in the book, Van Allsburg's house inspired the design of the Boy's house.

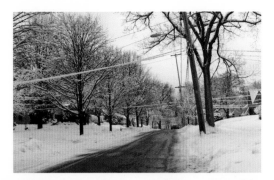

Snowy street in Michigan

Chris Van Allsburg's childhood home in Grand Rapids

It was very fortuitous to walk down Van Allsburg's old street and to actually go into the house—I even went into his bedroom. It helped make the design a little clearer as to the little bits of memory he was holding onto. And visiting the South Side neighborhood you could almost imagine opening a door and heading north to the woods outside Chicago where Bob went hunting with his dad, then up into the icy regions of Canada, heading to the North Pole.

—**Rick Carter**

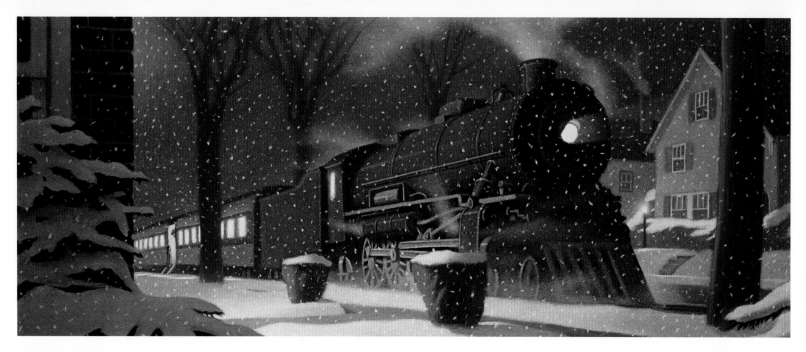

Illustration from
THE POLAR EXPRESS
Chris Van Allsburg
pastel

 emeckis's process began with his working up what'd eventually become a 250-page treatment. Ken Ralston, who'd first worked with Zemeckis on *Back to the Future* as an ILM visual-effects supervisor, recalled that story sessions typically featured Zemeckis sharing new sections of the treatment, which usually ended with a cliff-hanger situation. All the while, storyboard artists and Carter's and Chiang's art department teams kept bringing the written word to life with a flow of visual images. (Chiang estimates that about 90 percent of his department's work was produced on the computer.)

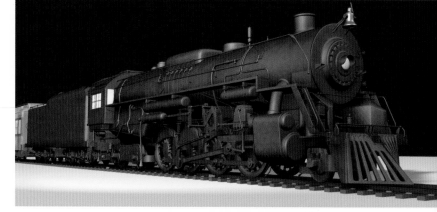

CG Train
**Sony Pictures
Imageworks
Fall 2002**
digital

"We gave a lot of thought to how to maintain the stylization that you have in the book," Sony effects supervisor Jerome Chen explains. "The pastel paintings in the book are impressionistic, with contrasty lighting and strong light sources and shadows. The question was, how stylized were we going to be?"

Sony Pictures Imageworks first ran a test to emulate the look of the book. "What we wanted was a world you could believe in, that down the street from the Boy's house and around the corner there were more houses, that there was a spatial believability and a world you'd think really existed," Ralston recalled. "So we applied this pastel, rough-hewn look in our initial test, making it textured, like a Van Allsburg painting. I thought I'd love it. But my initial response was: 'I hate it!' I wasn't expecting that."

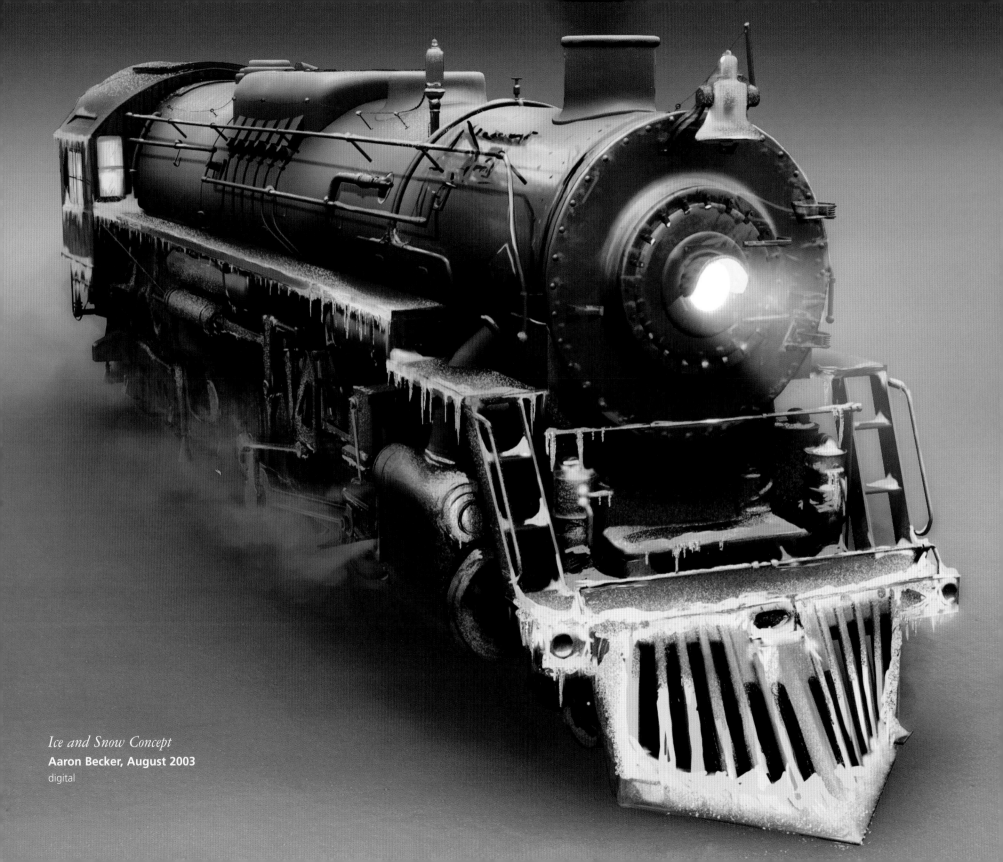

Ice and Snow Concept
Aaron Becker, August 2003
digital

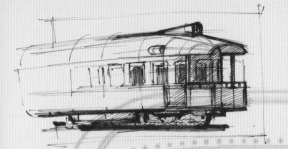

Observation Car
Art Department, 2003
sketches

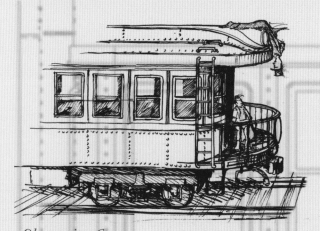

Observation Car
Art Department, 2003
sketches

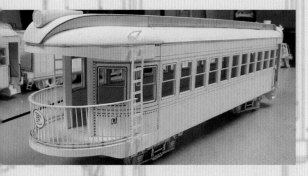

Observation Car
Art Department, 2003
card study model

he conceptual work was shared between Rick Carter, who headed a department at Culver Studios in Culver City, California, and Doug Chiang, who helmed a special unit in the Marin county town of San Rafael, in conjunction with Ken Ralston and Jerome Chen at Sony Pictures Imageworks.

Chiang had leapt at the chance to board the Polar Express. One lure was the project's inherent challenge, and another the chance to work with Zemeckis, Carter, Starkey, and the rest of the team. There was yet another reason—Chiang would get the chance to pull together a dream art department. It was an approach that'd been urged by Carter and Starkey. At the height of production, Chiang's unit had fifteen people, the players ranging from digital matte painters who hadn't specialized in design work to a three-person conceptual CG group.

"Typically, in preproduction you create flat, two-dimensional designs, whether it's pencil on paper or digital, and then develop the designs in physical miniature models or on the computer," Chiang recalled. "On this film we did all that *concurrently*. Sometimes we'd draw and develop designs and make a CG model, other times we made a CG model first and then developed the design and paint scheme. This way, we were able to give Bob, at a very early stage, precisely what the finished product would look like. We could lock in all the information, from composition and color design to lighting and set dressing, so the Sony team knew how much work they'd need to do on any given design. To my knowledge, this was the first time an art department essentially merged the 2-D work of preproduction and the 3-D design of postproduction."

[opposite]
Observation Car
Mark Sullivan, April 2003
digital

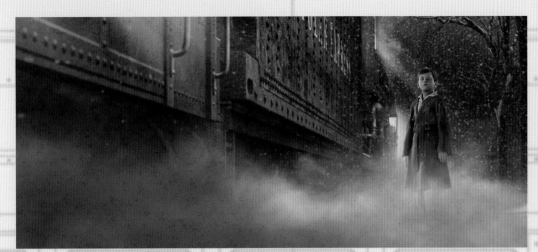

Film Final
Sony Pictures Imageworks

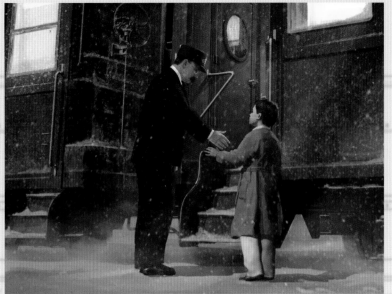

Boy and Conductor
Bill Mather, April 2003
digital

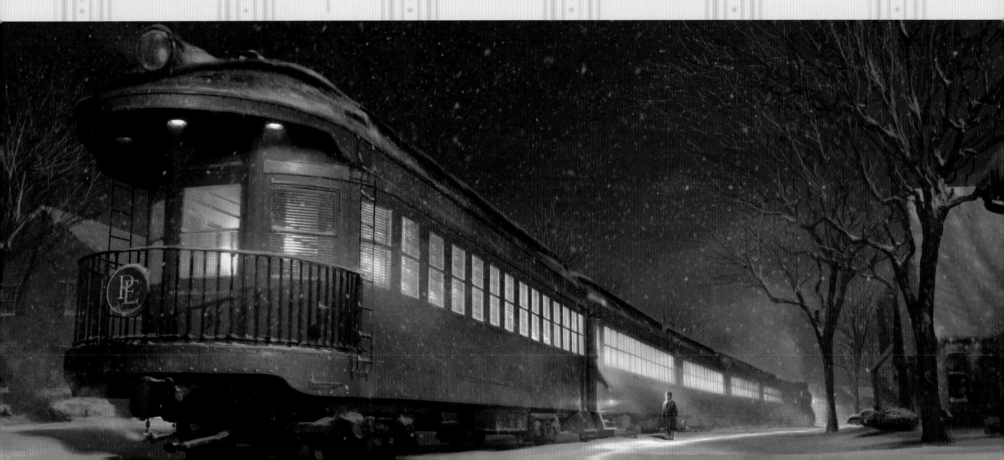

Boy and Train
Bill Mather, May 2003
digital

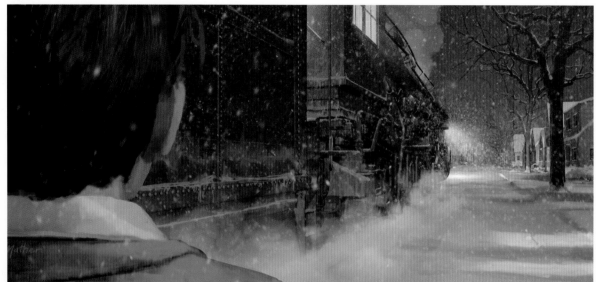

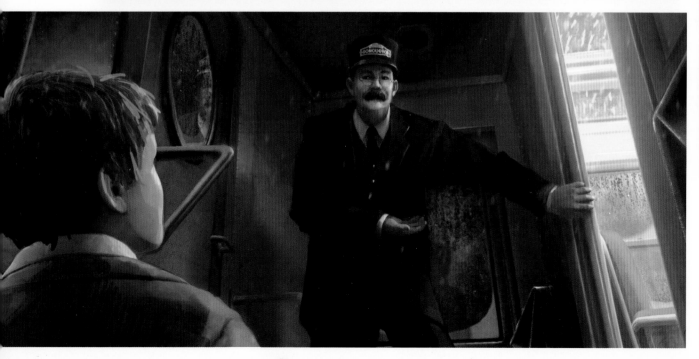

Conductor and Boy
Randy Gaul and Bill Mather
April 2003
digital

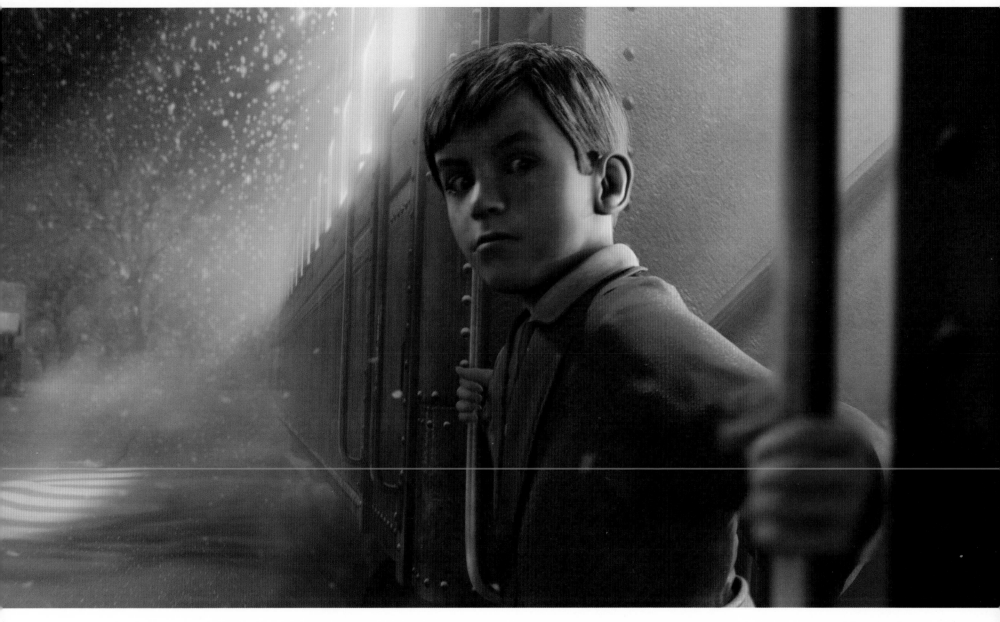

Film Final
**Sony Pictures
Imageworks**

In a film like this, every frame was a painting, that's how I approached it. Jerome and I would take Doug's concept work and then move forward into the world of CG, where we'd build the 3-D sets. That's what I'm most interested in, the lighting of each scene, creating the atmosphere, the effects work that makes sparks come off the train's wheels or the snow fall a certain way, so it's always lyrical, magical.

—Ken Ralston

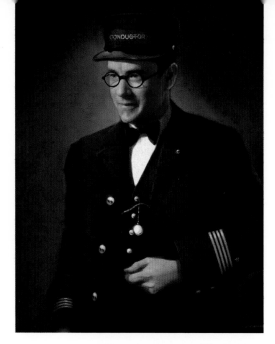

Conductor Development
Doug Chiang, April 2002
digital

ony Pictures Imageworks presented Zemeckis with three options for how to make the movie. One had actors performing in costume against bluescreen backing, that neutral background that would then be replaced with wholly computer-generated environments. Another idea was to stage a conventional live-action production with actors in real sets, scan the resulting footage into the computer, and digitally texture the images for a painted, storybook effect. The third, and ultimately best, option for Zemeckis's consideration was saved for last—performance capture.

Three special performance-capture stages were set up at Culver Studios. The technology stripped the process down to bare essentials. Joanna Johnston's costumes would be scanned into the computer and worn by the digital incarnations of the actors, so the performers only had to wear special motion-capture suits. Each suit was marked with reflective "front projection" balls that served to bounce back infrared lights shooting out from each of some eighty cameras attached to computers recording every bit of motion data. There were no elaborate physical sets to build, only basic shapes for key set pieces and props. There were no lights to rig as the actual cinematography would come later in the computer.

The breakthrough for *The Polar Express* was the integration of "body capture" and "close-up capture." The latter allowed for motion cameras to record every nuance of facial expression through some 150 dotlike bits of front-projection material the performers wore on their faces. The resulting data for body and facial movements, which looked like a mass of points moving in the virtual space of the computer, could be synched together and then digitally applied to corresponding points on Sony's 3-D, computer-generated character models (with Sony's character designer Vladimir Todorov leading the digital design effort). Since performance data could be scaled, every detail of Tom Hanks's performance as a young boy could correspond to the computer-generated character models that Sony created.

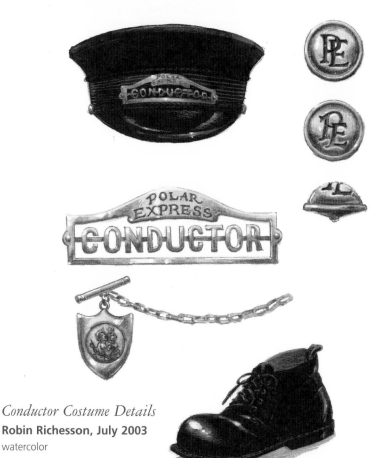

Conductor Costume Details
Robin Richesson, July 2003
watercolor

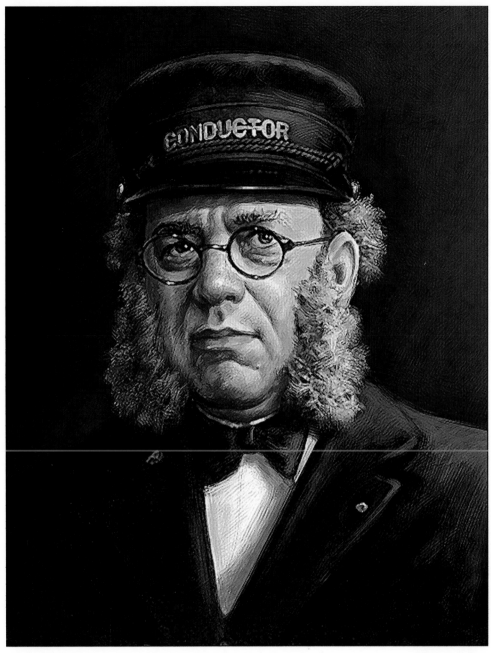

Conductor Development
Vladimir Todorov
May 2002
digital

Vladimir

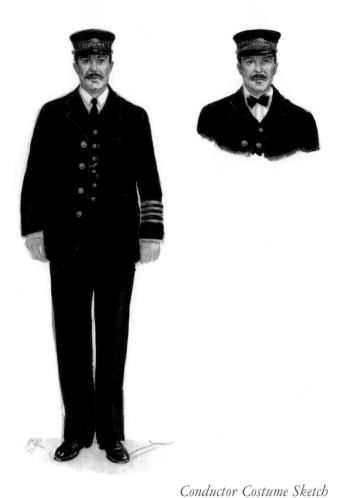

Conductor Costume Sketch
Robin Richesson, July 2002
watercolor

Very early on, Bob suggested I play all the parts. We did a full day of tests of the mo-cap [motion-capture] process in which I played all the main male roles. The final result was I play the Boy and the main adult male characters he interacts with—his Father, the Conductor, the Hobo, and Santa. All these characters carry with them the meaningful weight of the story, they spring from the Boy's own consciousness.

—Tom Hanks

Tom Hanks Wardrobe Fitting
May 2003

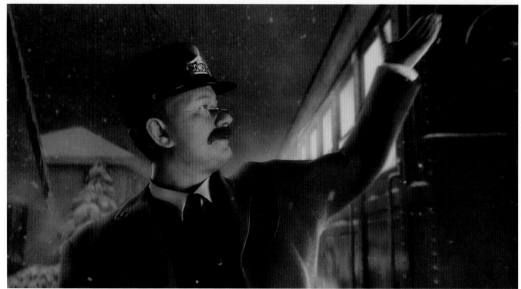

Everyone on the production had to use their imagination each day, they had to create the look and sound of the movie in their heads in lieu of the gray grid, which was all we saw [on the performance-capture stage]. Then, as the movie went through the postproduction process, we weren't finished with working on the film. We saw our imaginings coming to reality every day. This is different from a traditional film where sets are torn down and costumes put away. Our dreams were always at work.

—**Tom Hanks**

What was frustrating for me was the lack of costumes, which can inspire a lot of great, unplanned moments. I found I had to change *something* from one character to the next, and since I couldn't get out of my Lycra mo-cap suit the only option was my shoes. I wore running shoes when I performed as the Boy and different pairs of boots when I played the Conductor, the Hobo, and Santa. The change of shoes affected my posture and my movement and, in the final result, my character.

—**Tom Hanks**

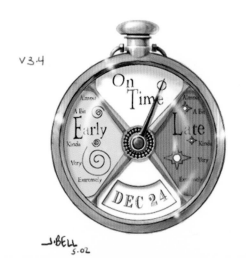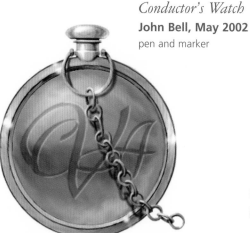

Conductor's Watch
John Bell, May 2002
pen and marker

*Train
Vestibule
Lighting*
**Randy Gaul
March 2003**
digital

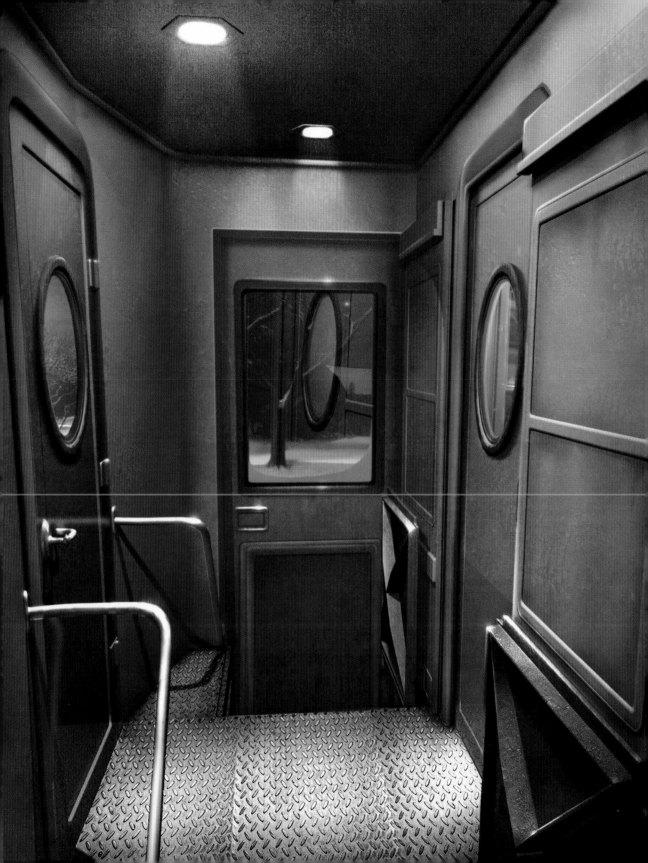

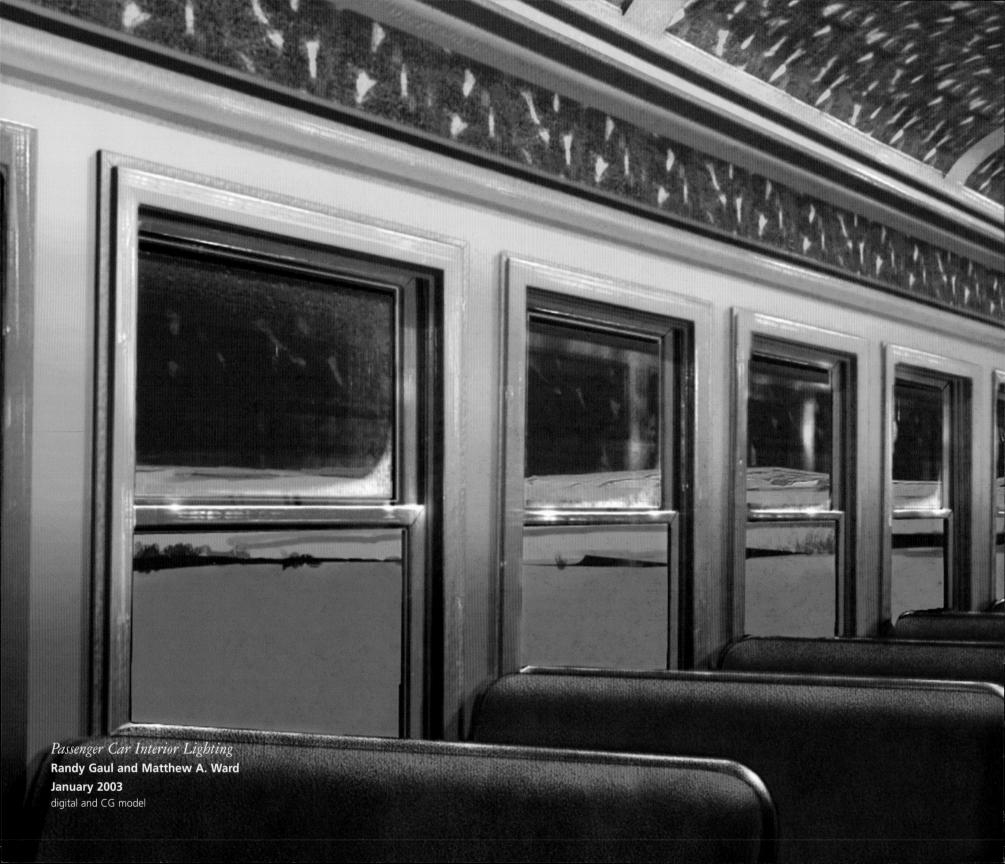

Passenger Car Interior Lighting
Randy Gaul and Matthew A. Ward
January 2003
digital and CG model

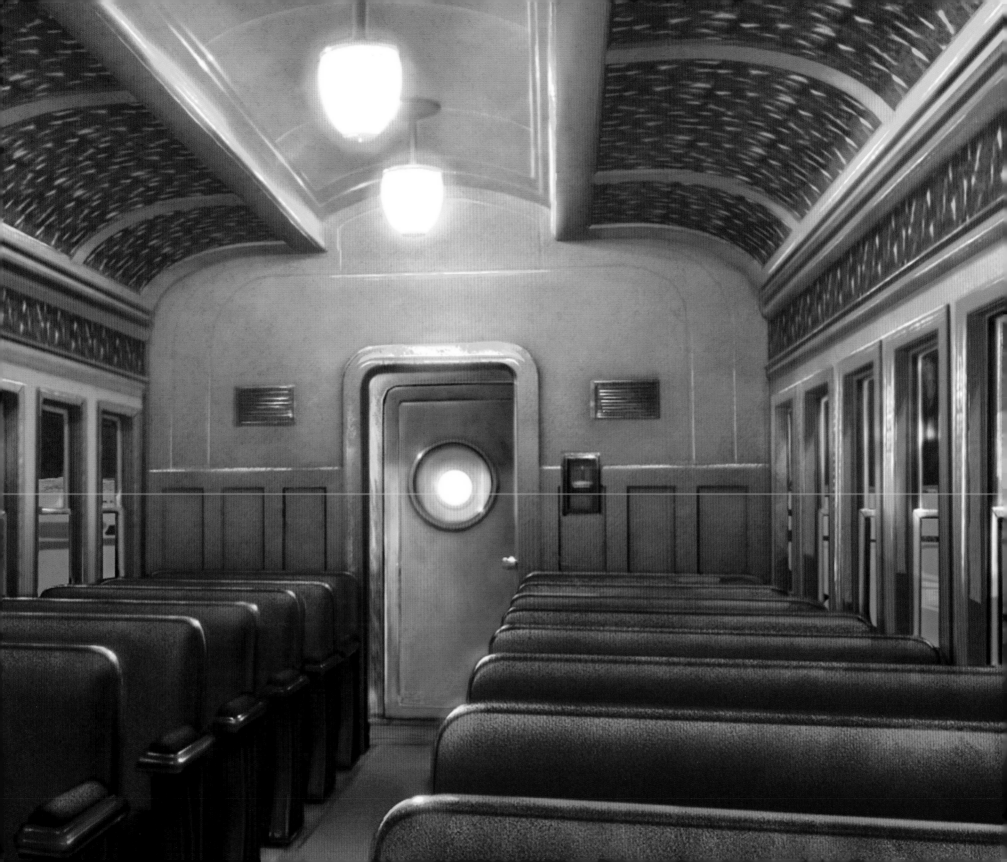

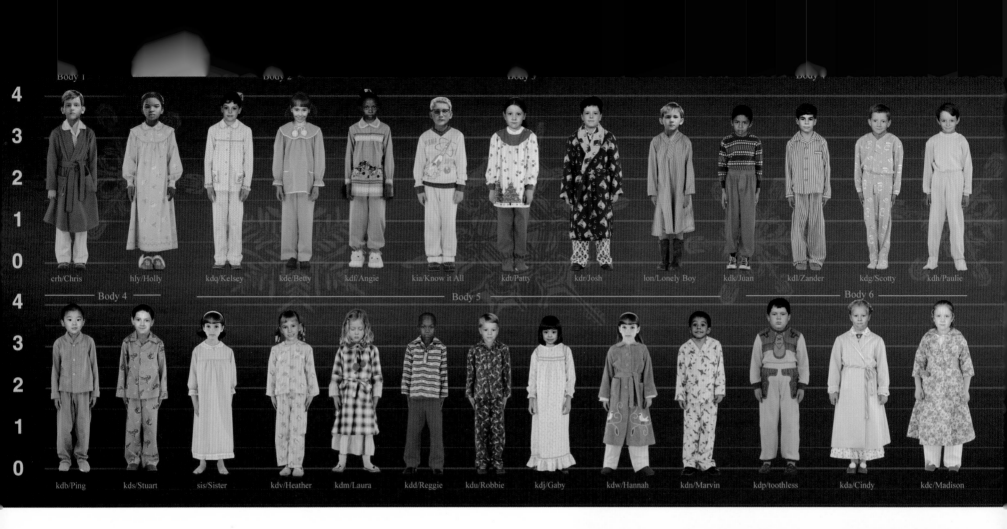

Body 1 Body 2 Body 3 Body 4

crh/Chris hly/Holly kdq/Kelsey kde/Betty kdf/Angie kia/Know it All kdt/Patty kdr/Josh lon/Lonely Boy kdk/Juan kdl/Zander kdg/Scotty kdh/Paulie

Body 4 Body 5 Body 6

kdb/Ping kds/Stuart sis/Sister kdv/Heather kdm/Laura kdd/Reggie kdu/Robbie kdj/Gaby kdw/Hannah kdn/Marvin kdp/toothless kda/Cindy kdc/Madison

I did my normal process, working with Robin Richesson, my costume artist, on the designs, and then my genius department physically made each costume. But I worked closely with Sony Pictures Imageworks. There were things to avoid, like ruffles and light and baggy outfits, because anything with a dimensional quality becomes very complicated in the computer. There was a scanning process, with performers wearing leotards or underwear, which became the foundation for the [CG model] body. Imageworks would then scan in the real textures and map on the costumes. In the computer we could more economically take one body and dress it in four different sets of clothing—and different heads. It was a cut-and-paste process or, as I called it, "the decapitation process."

—Joanna Johnston

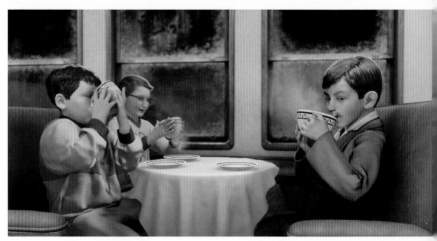

Film Final
Sony Pictures Imageworks

[opposite]
**Character-model sheet of
children of** *The Polar Express*

Hero Boy Costume
Robin Richesson
watercolor

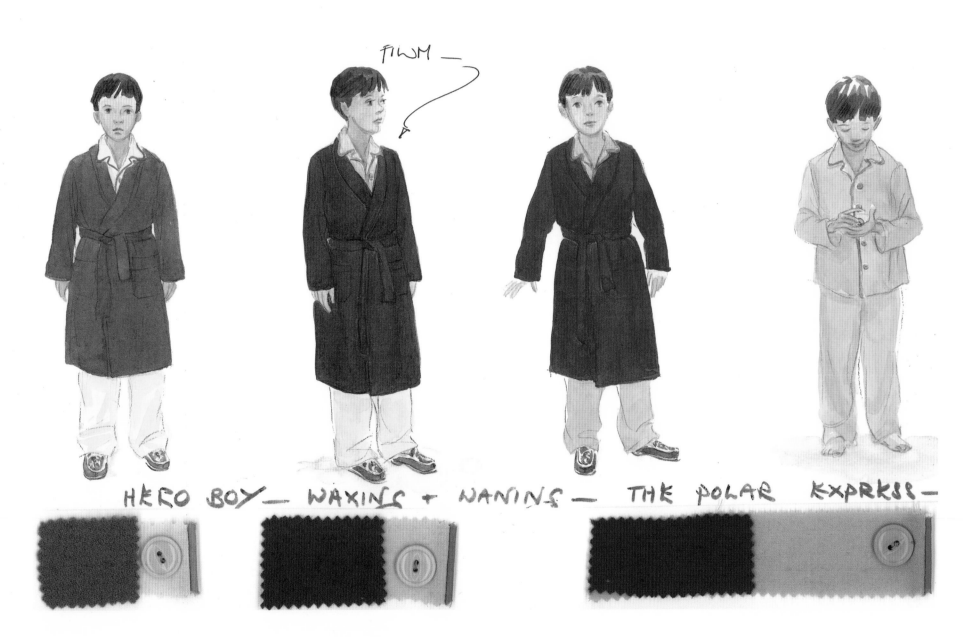

FILM —

HERO BOY — WAXING + NANING — THE POLAR EXPRESS —

Film Final
**Sony Pictures
Imageworks**

Holly Costume
**Robin Richesson
April 2003**
watercolor

*Know-It-All
Costume*
**Robin Richesson
April 2003**
watercolor

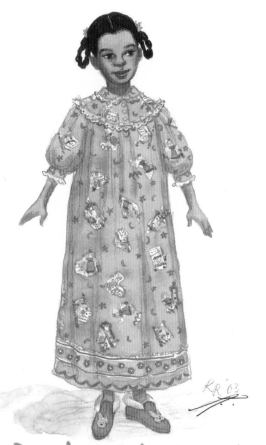

POLAR EXPRESS — KNOW IT ALL

Film Final
Sony Pictures Imageworks

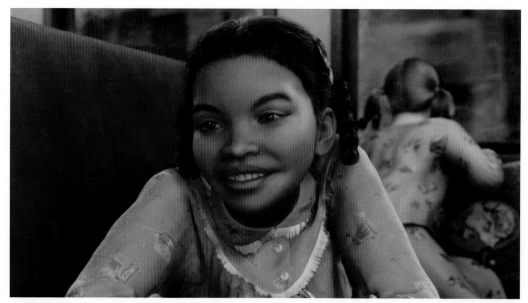

POLAR EXPRESS - HOLLY

34

Film Final
Sony Pictures Imageworks

The hero Boy, with his blue robe and yellow pajamas, was the one character more or less lifted straight from the book and Chris Van Allsburg's illustrations.

The Girl {performed by Nona Gaye} was inspired by the illustration in the book of the girl who sits next to the Boy on the train ride home. There was a fifties feel to her outfit and she was very girlish and sweet, with her nightdress and bunny slippers.

Bob was very specific about Lonely Boy {performed by Peter Scolari}—he's from the wrong side of the tracks. He's getting hand-me-down clothing, he looks a little rough. While all the other boys on the train wear pajamas, he's wearing a faded old nightshirt, which is very vulnerable looking for a boy and which set him apart from the clarity and bursts of color we see in the clothing of the other boys.

Know-It-All Boy {performed by Eddie Deezen} is confident, cocky—explosive! Since the film is {referencing} the 1950s, I had the idea of reflecting the early- to mid-fifties exploration of space in his pajamas, which have this big image of a rocket ship. These characters were clearly defined by Bob. The look of the rest of the children I ran with, using the book as a loose blueprint, but I stayed in a 1950s range of clothing styles.

—**Joanna Johnston**

Film Final
Sony Pictures Imageworks

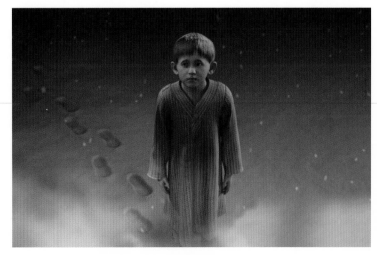

Hot Chocolate Storyboards
Phillip Keller
pen and ink

In the book the kids are simply going to get hot chocolate on their way to the North Pole, but in our movie it's a big production number. The hot chocolate sequence is an incredible song-and-dance routine, and it stemmed from that one picture in the book.

—Jerome Chen

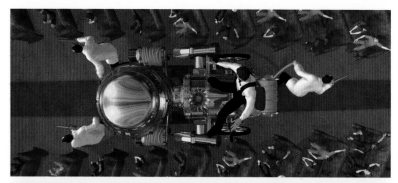

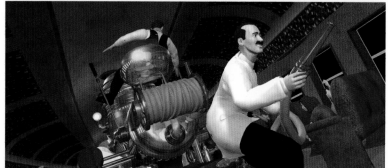

Hot Chocolate Dance Number Digital Storyboards
Matthew A. Ward, May 2002
CG model

Early Hot Chocolate Machine
Matthew A. Ward, April 2002
CG model

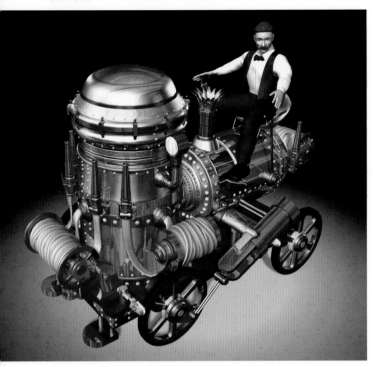

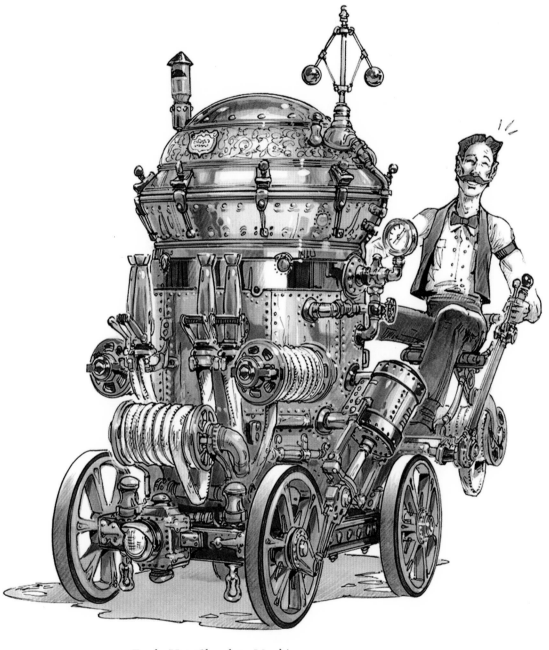

Early Hot Chocolate Machine
Marc Gabbana, April 2002
pen and marker

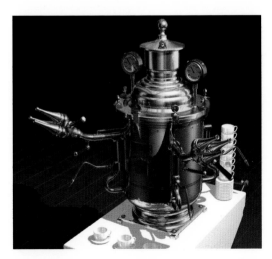

Final Hot Chocolate Machine
Zac Wollons, March 2003
CG model

Bob always wanted each character's ticket to be significant, it was always going to be this weird, dream ticket. The original idea was that the Conductor would punch in a word that always read backward, no matter which side the letters were on. That changed at one story meeting when Bob decided the gag could backfire if some kid in the audience could simply read backward. So, the final ticket is more cryptic; it reveals a few letters that only at the end spell out the word, the lesson each child must learn.

—Doug Chiang

Preliminary Ticket Design
Marc Gabbana, November 2002
digital

Final Ticket Design
Marc Gabbana, December 2002
digital

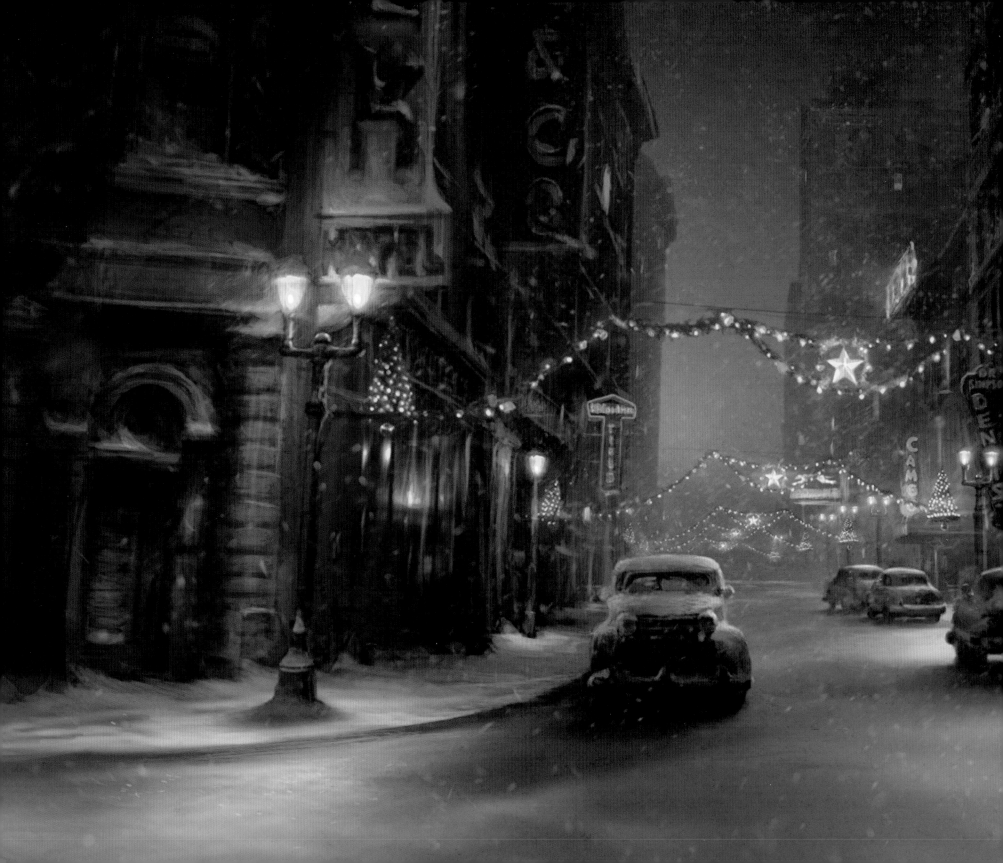

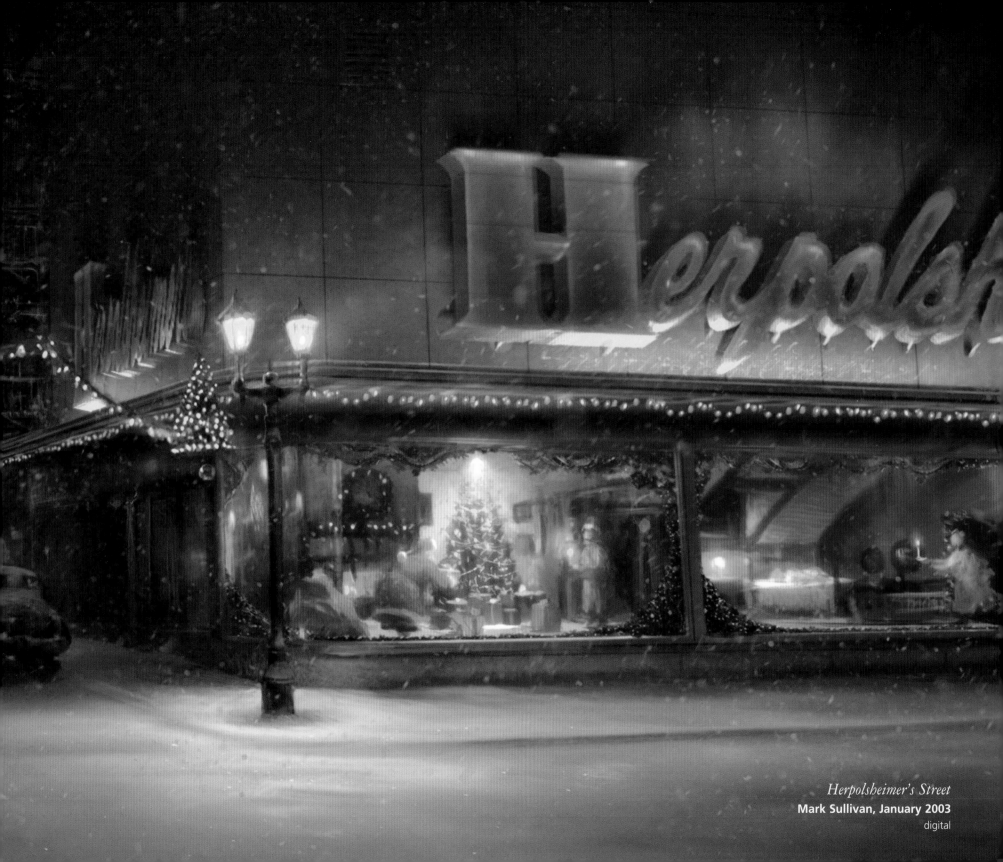

Herpolsheimer's Street
Mark Sullivan, January 2003
digital

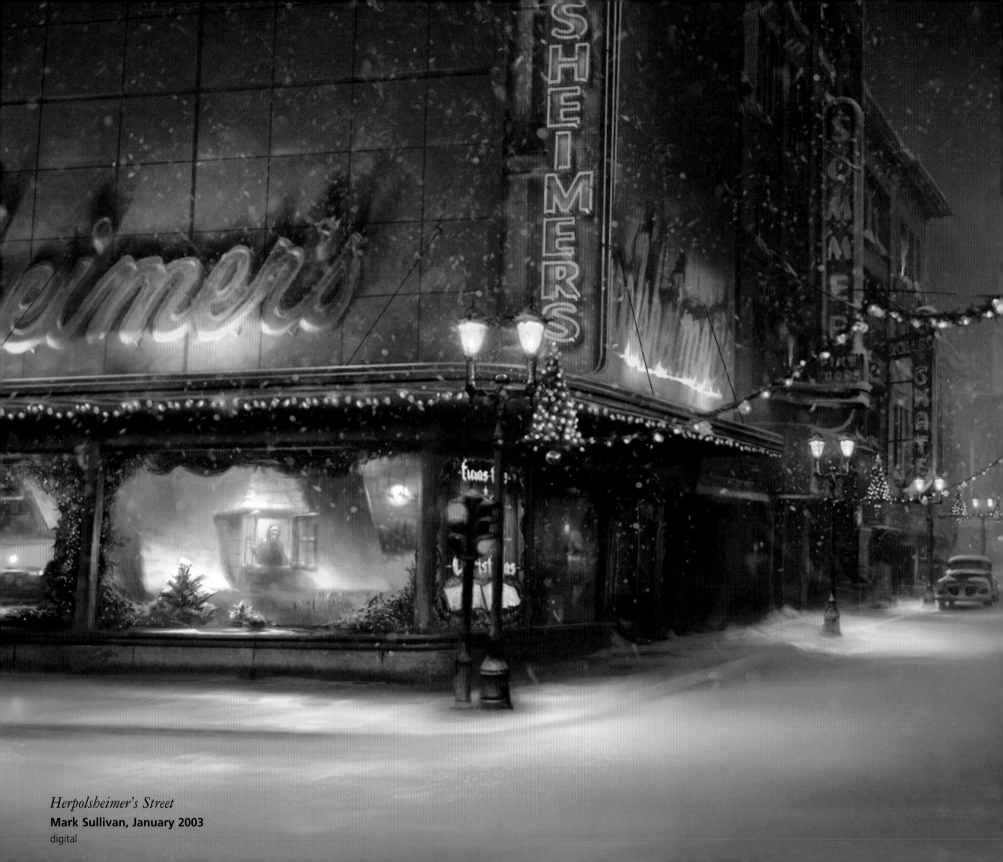

Herpolsheimer's Street
Mark Sullivan, January 2003
digital

Bob's day-to-day life as a kid revolved around this little area of the city that had its own downtown and a department store similar to the Herpolsheimer's that Chris knew in Grand Rapids. So, the foundation idea for the shape and imagery of the Boy's town in the movie became this blended imagery of Bob's and Chris Van Allsburg's hometowns. It seemed better to find real-life things that had an inherent resonance and make that the starting point for our creative exploration, and that's what we did.

—Steve Starkey

Downtown street with Christmas decorations

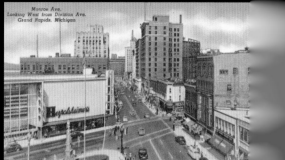

Postcard of Grand Rapids

Here we have the Boy and the dramatic tension of being on the edge of losing that sense of wonder because reality is starting to come through. What Bob is very good at is making a movie that's vibrating right on that edge of belief and non-belief—there's a sense of not only suspending disbelief but a skeptical voice to keep things honest.

—Rick Carter

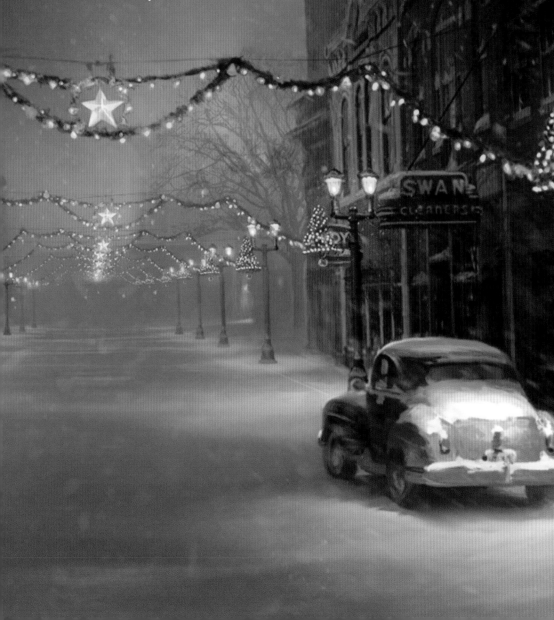

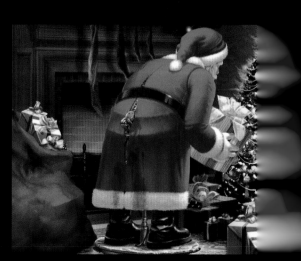

Store Window Display
Randy Gaul and Marc Gabbana January 2003
digital

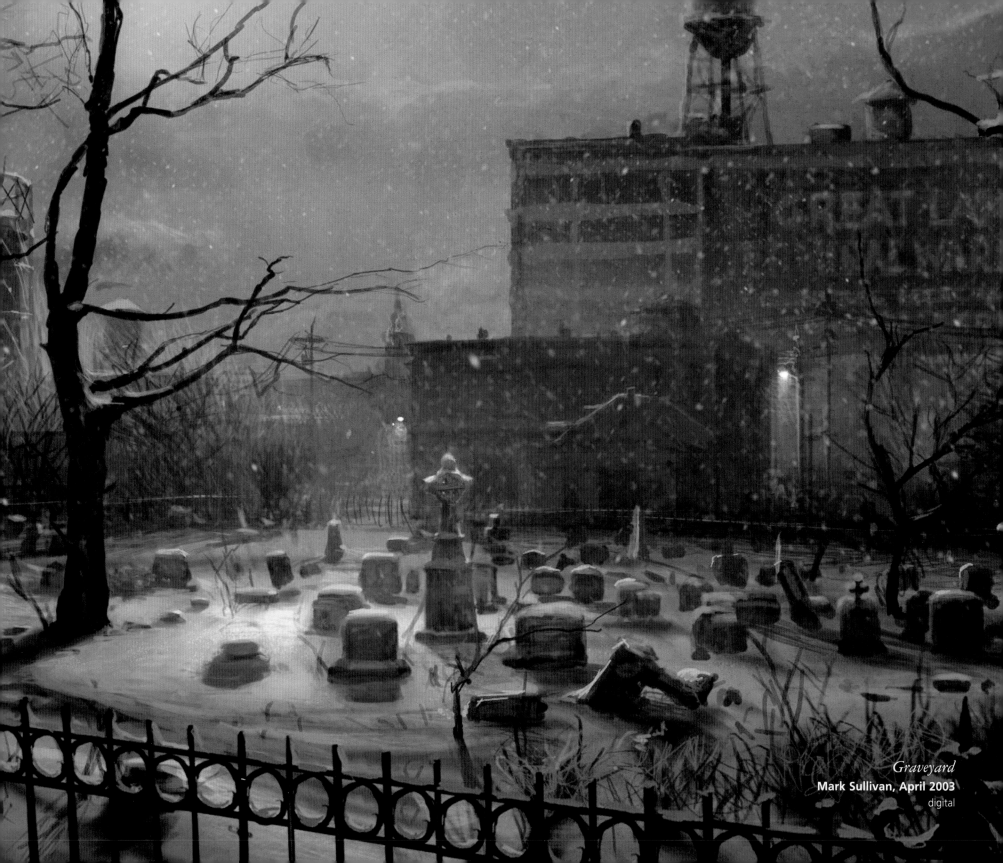

Graveyard
Mark Sullivan, April 2003
digital

Back Alley
Mark Sullivan, June 2003
digital

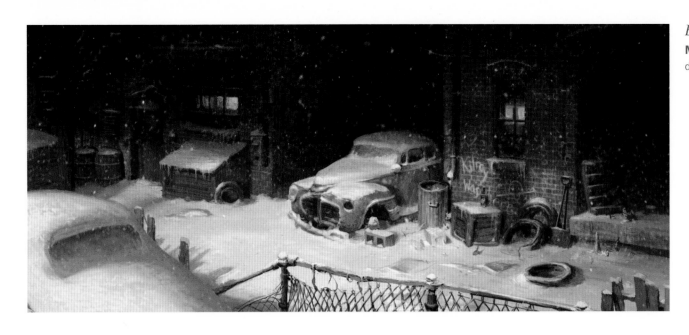

Final Lonely Boy Neighborhood
Aaron Becker, June 2003
digital

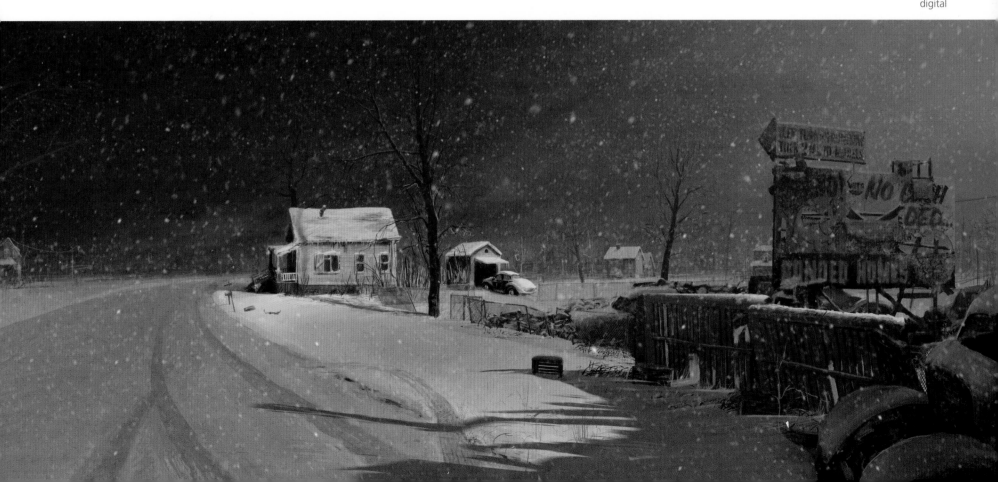

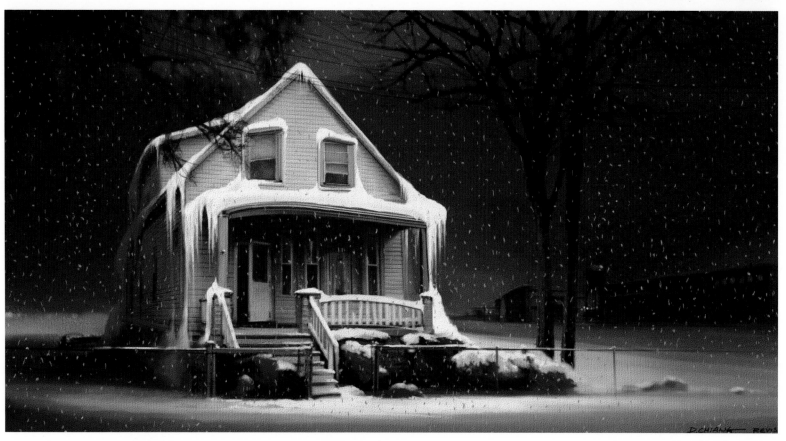

Preliminary Lonely Boy House
Doug Chiang, March 2002
digital

In Chicago, Rick Carter found the perfect inspiration for the Lonely Boy's house two doors down from Zemeckis's boyhood home. It was ultimately placed in the imaginary world of the film near a graveyard on the gloomy outskirts of town, its top two windows looking out on the world like sad eyes.

—**Steve Starkey**

Lonely Boy House reference

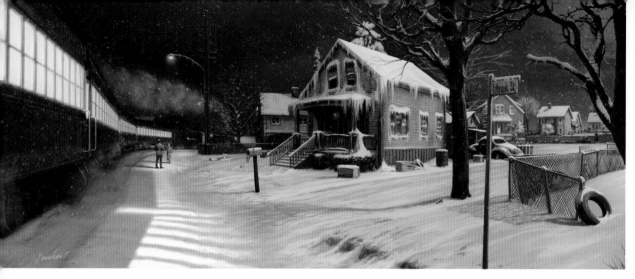

Lonely Boy House Development
David Saccheri, January 2003
digital

Preliminary Observation Car
Doug Chiang, April 2002
digital

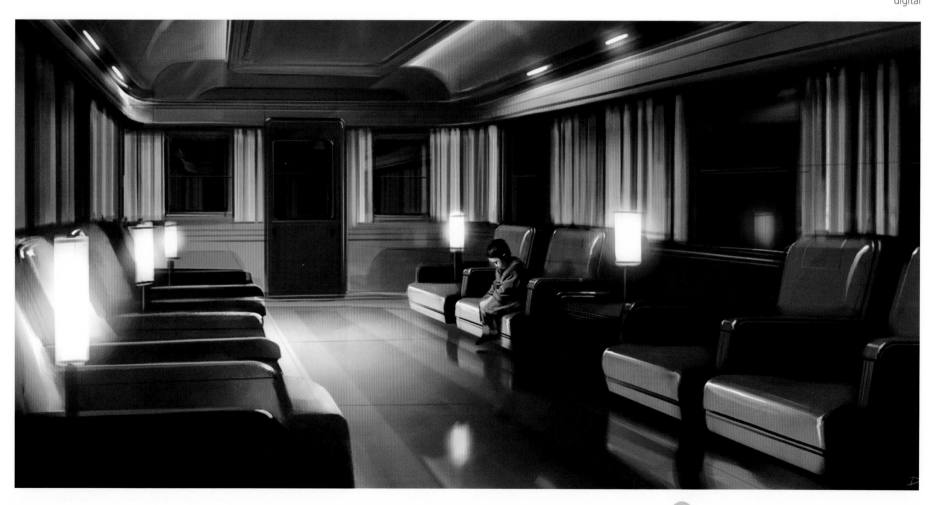

 n one flight of fancy, the Girl's ticket flies out of the train and goes on its own magical journey. The ticket makes its way back to the train, sucked into a vent where the Boy grabs it. But in the meantime, the Conductor has put the ticketless Girl to work in the front engine car. To bring her the ticket, the Hobo and the Boy have to ski atop the train from the back observation car—and get to the engine before they literally hit Flat Top Tunnel.

Boy Outside the Train
Mark Sullivan, March 2003
digital

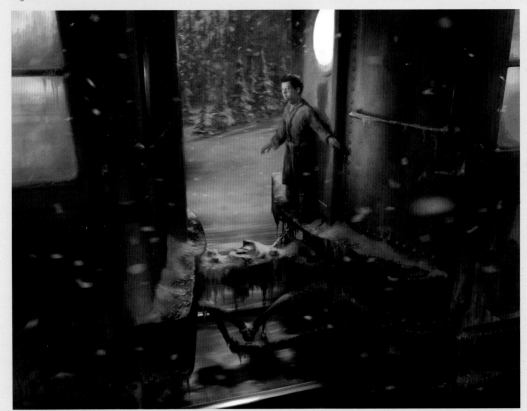

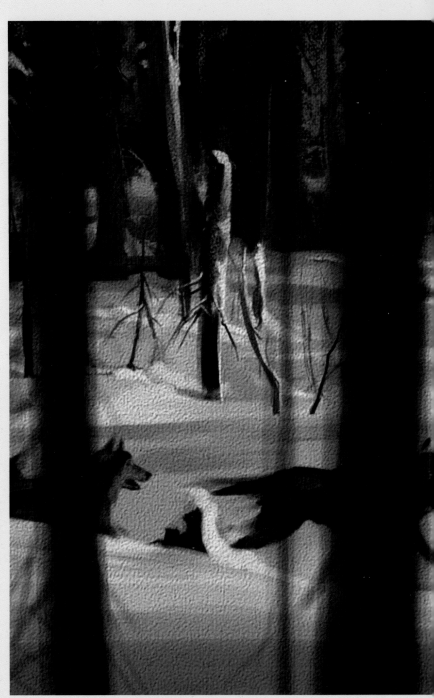

Early Ticket Journey
Doug Chiang, March 2002
digital

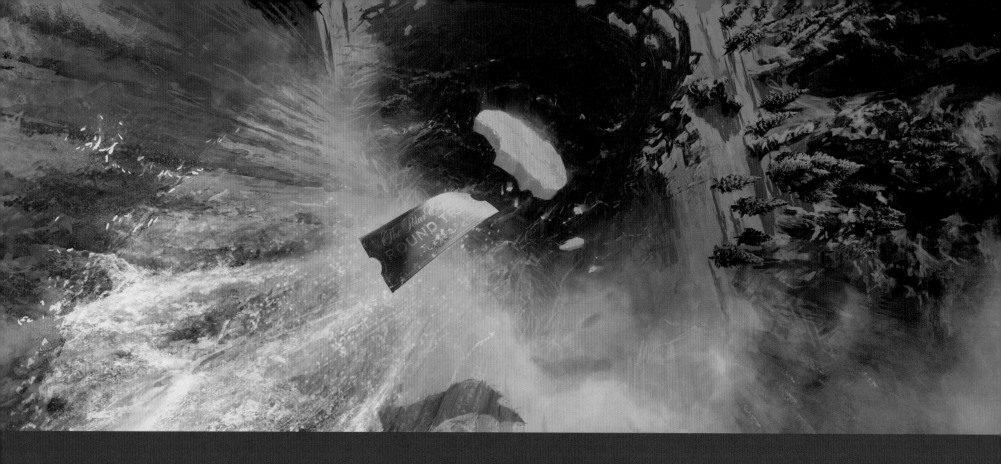

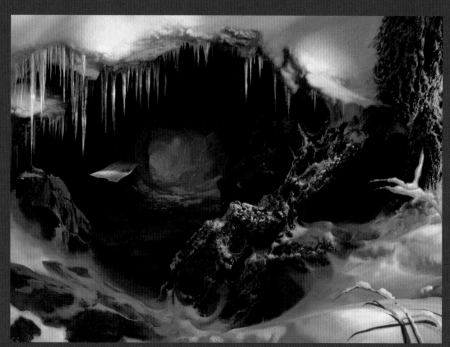

Ticket Journey
Aaron Becker, March 2003
digital

Ticket Journey
Randy Gaul, March 2003
digital

Rick focused on interior sets of the Boy's house and elements of the North Pole where there'd be a lot of performance-capture interaction, and I leapt into designing the set pieces for the whole journey, from the outskirts of the town to the big environments. From focusing our energies on different parts of the show at the beginning, we then slowly merged our efforts. It became a very fluid process once we got going.

—Doug Chiang

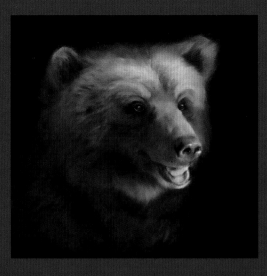

Bear Concept
Doug Chiang, March 2002
digital

Early
Bear Jam Concept
Doug Chiang
April 2002
digital

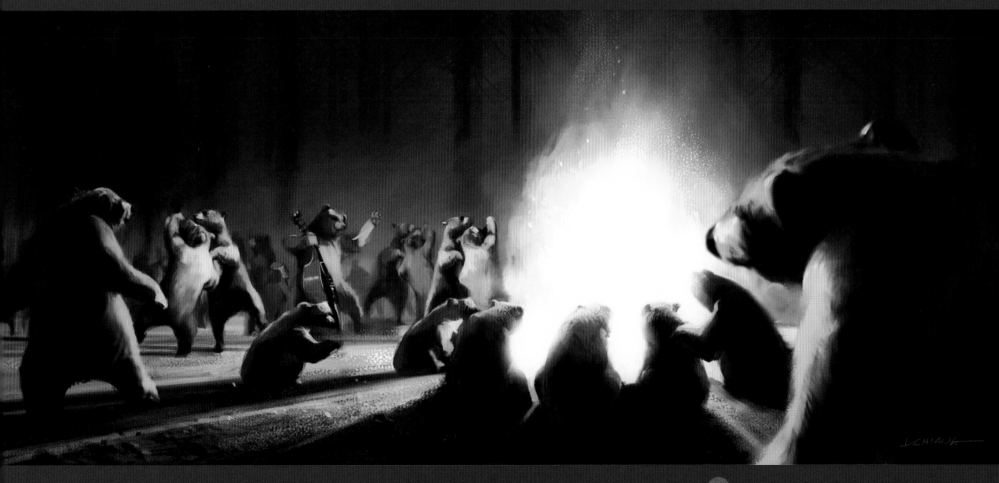

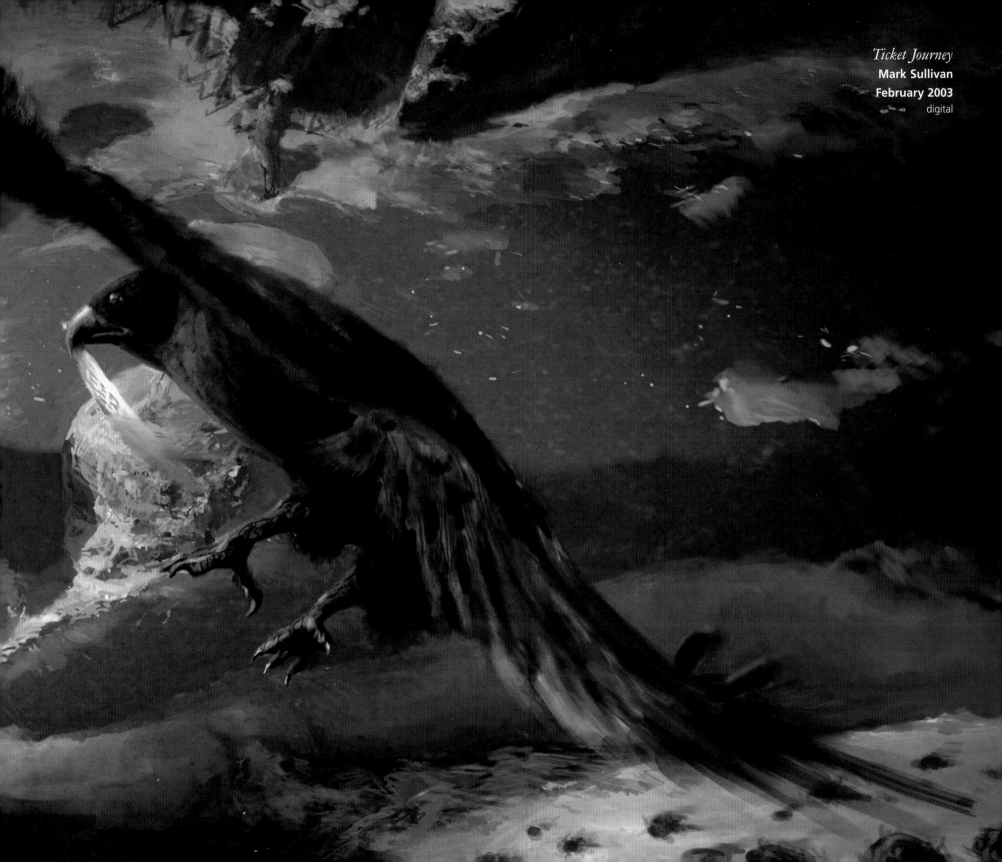

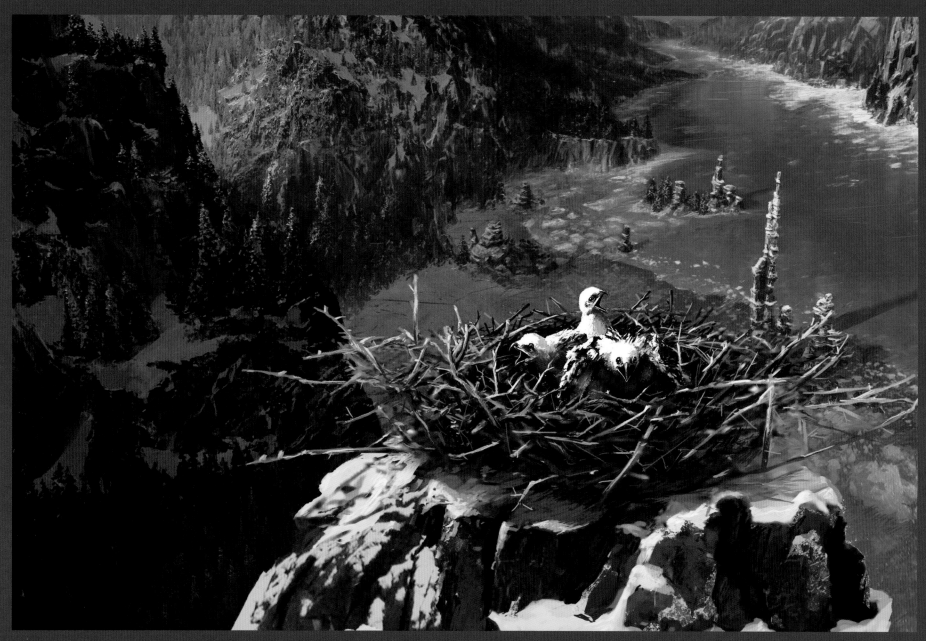

Eagle Nest
Aaron Becker, March 2003
digital

In normal live-action cinema the place setting is defined by the art director and design department and then brought to life by a cinematographer, who further defines the tone of the image through lighting. In this movie, the color and lighting aspect of cinema was done by Doug and his art department team and executed by Ken Ralston at Sony with the camera work [in the computer] being directed by Bob. So, the camera operation is happening in this three-dimensional, virtual space, but the color and lighting that brings it to life is done in the art department, which is a radical departure from normal cinema.

—Steve Starkey

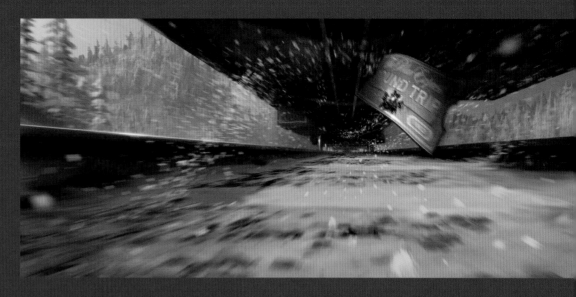

Ticket under Train
Mark Sullivan, July 2002
digital

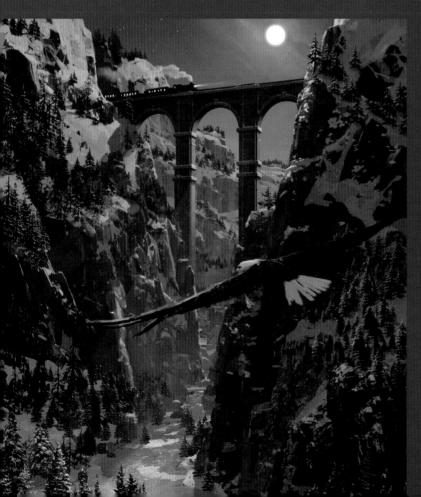

Ticket Journey
Bill Mather, March 2003
digital

Hobo under Train
Marc Gabbana, July 2003
digital

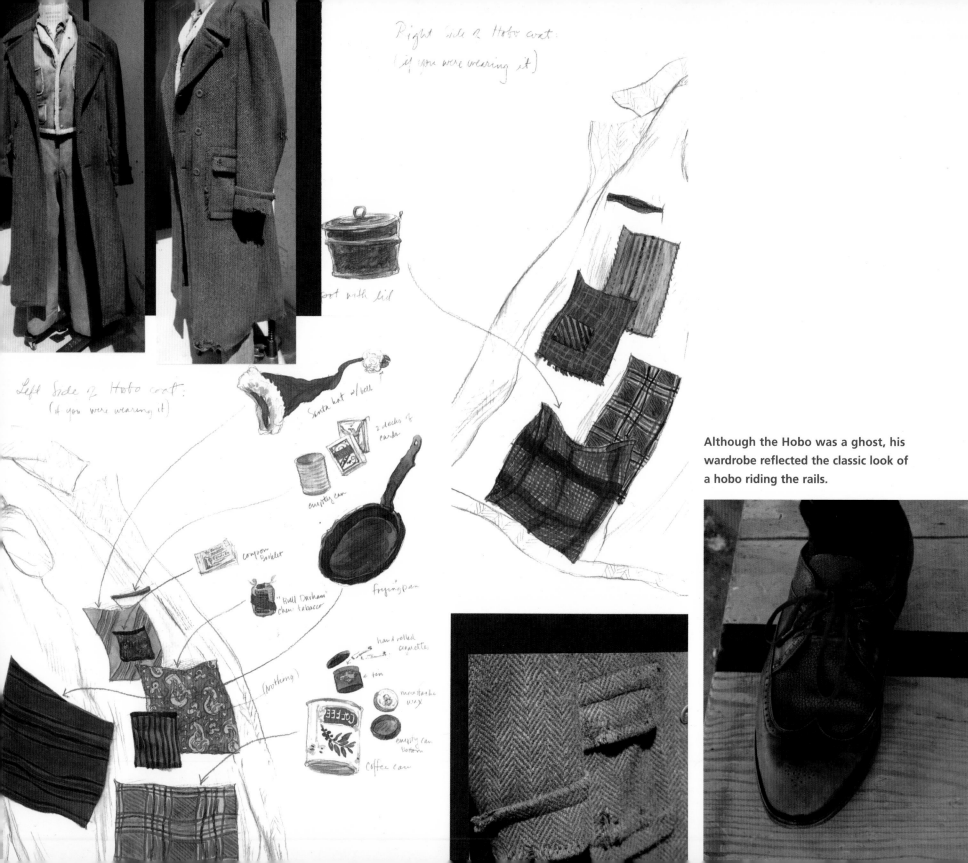

Right side of Hobo coat:
(if you were wearing it)

Left side of Hobo coat:
(if you were wearing it)

pot with lid

Santa hat w/ bell

2 decks of cards

empty can

coupon booklet

"Bull Durham" chew tabacco

frying pan

hand rolled cigarette

ten

moustache wax

(nothing)

empty can bottom

COFFEE

coffee can

Although the Hobo was a ghost, his wardrobe reflected the classic look of a hobo riding the rails.

It [the performance capture] was fantastic! But it took me a little while to understand that things were very fungible. I have a lifetime of conditioning where when the actor walks away and we say "Wrap," what you've got is what you've got. So I was suffering a little bit at first, trying to make things work within the parameters of what I captured. Then I learned it was much more liberating. But I had to be disciplined because now there were no excuses—no bad weather or trains not hitting their mark—for not making each shot *perfect*.

—Robert Zemeckis

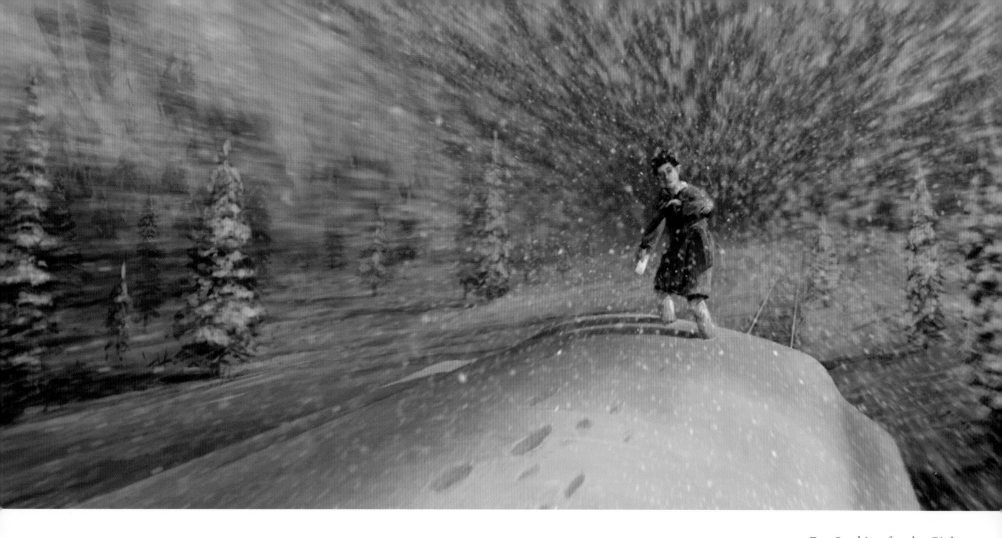

Boy Looking for the Girl
Aaron Becker, May 2003
digital

What Doug and his group achieved with their imagery took production design out of questions I'm used to—mainly "Why?" and "What?"—and showed how something could look in the final film frame. It was a whole new realm where things like the color palette and lighting design was very specific. This process happens in animation, but the difference is, with our live-action performance capture, we were also drawing on the real world.

—**Rick Carter**

Boy on Train Top
Bill Mather, July 2003
digital

The Hobo asks the Boy, "What do you think about the Big Man?" The Boy wants to believe in Santa Claus, but the Hobo says, "Seeing is believing." The Hobo makes fun of the Boy's struggle to believe, taps into his doubt.

—Steve Starkey

Hobo Skiing
Aaron Becker, February 2003
digital

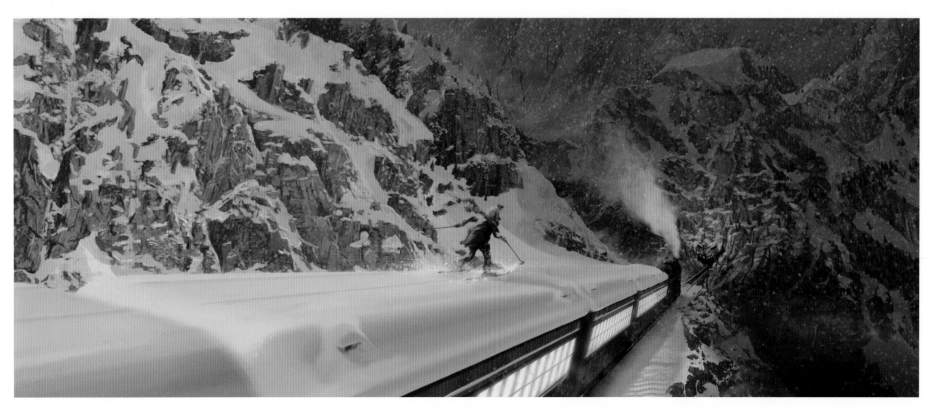

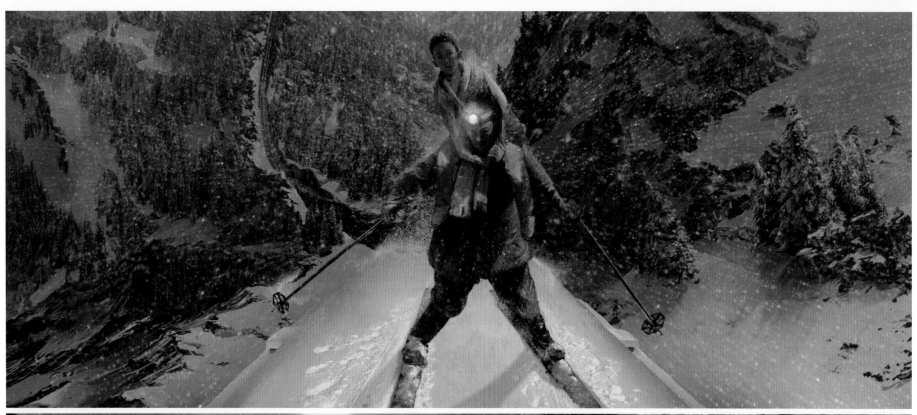

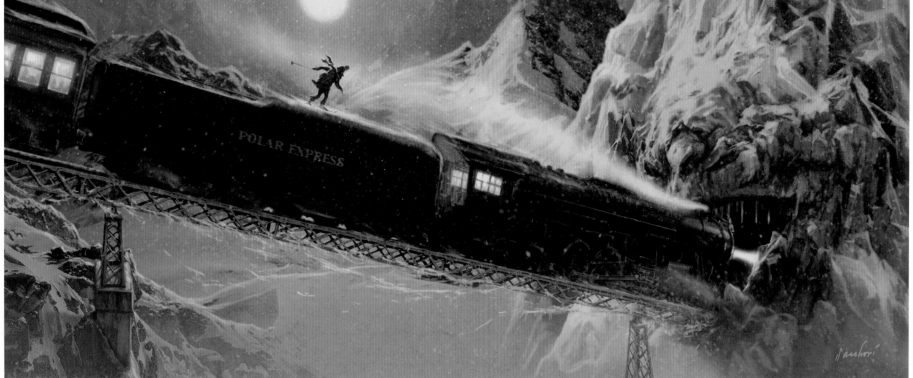

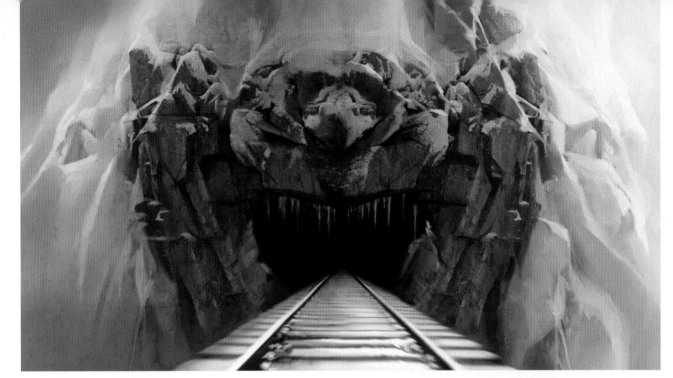

Early Flat Top Tunnel
Doug Chiang, March 2002
digital

Hobo Skiing Environment
Mark Sullivan, October 2003
digital

In a live-action movie, you might use one location over and over again, but you're clever about where you're moving the camera so the audience doesn't realize you're going over the same piece of ground. We had to have the same mentality with the 3-D environments.

For the sequence of the Hobo skiing atop the train we made a 3-D set that was basically scaled to a couple of square miles. It was enormous, but we were smart about it; it wasn't an unwieldy digital model where you don't get to see two-thirds of the details.

—Jerome Chen

[opposite, top]
Hobo Skiing
Aaron Becker, February 2003
digital

[opposite, bottom]
Flat Top Tunnel Entrance
David Saccheri, February 2003
digital

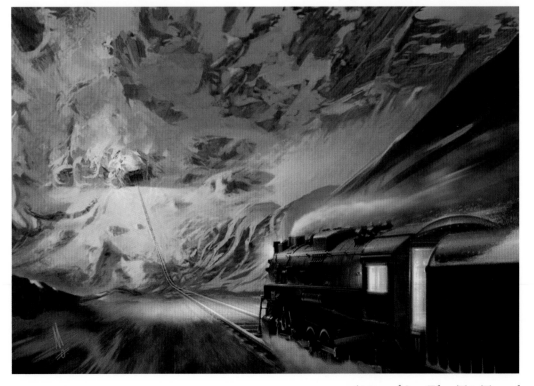

Approaching Flat Top Tunnel
Marc Gabbana, November 2003
digital

When Michael Jeter came in for a casting call, he performed both the characters of Smokey and Steamer. Bob was so excited that he cast Michael for both roles on the spot.

—**Steve Starkey**

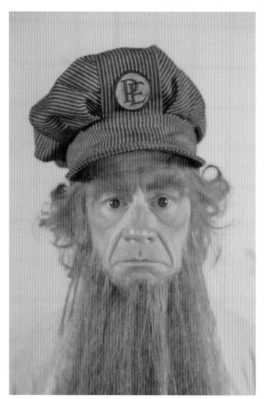 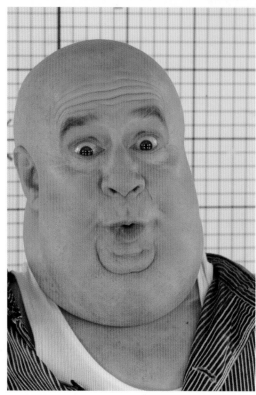

Michael Jeter make-up test for Smokey and Steamer.

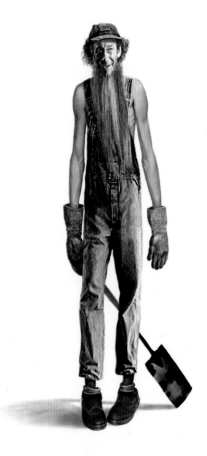

Smokey Concept
Vladimir Todorov, January 2003
digital

The idea Bob came up with for Smokey and Steamer was these characters were opposite caricatures of each other: Smokey is like seven feet tall and skinny, with this flaming red beard, and Steamer weighs over four hundred pounds and is four feet tall. Their clothing was based on the utilitarian clothing real guys would wear in an engine room, but there's a lot of witty little things on their costumes, such as these embroidered labels on their overalls—Smokey's reads "Long Utility Wear" and Steamer's reads "Wide Wear."

—**Joanna Johnston**

[opposite]
Engine Cab
Bill Mather and Zac Wollons
January 2003
digital

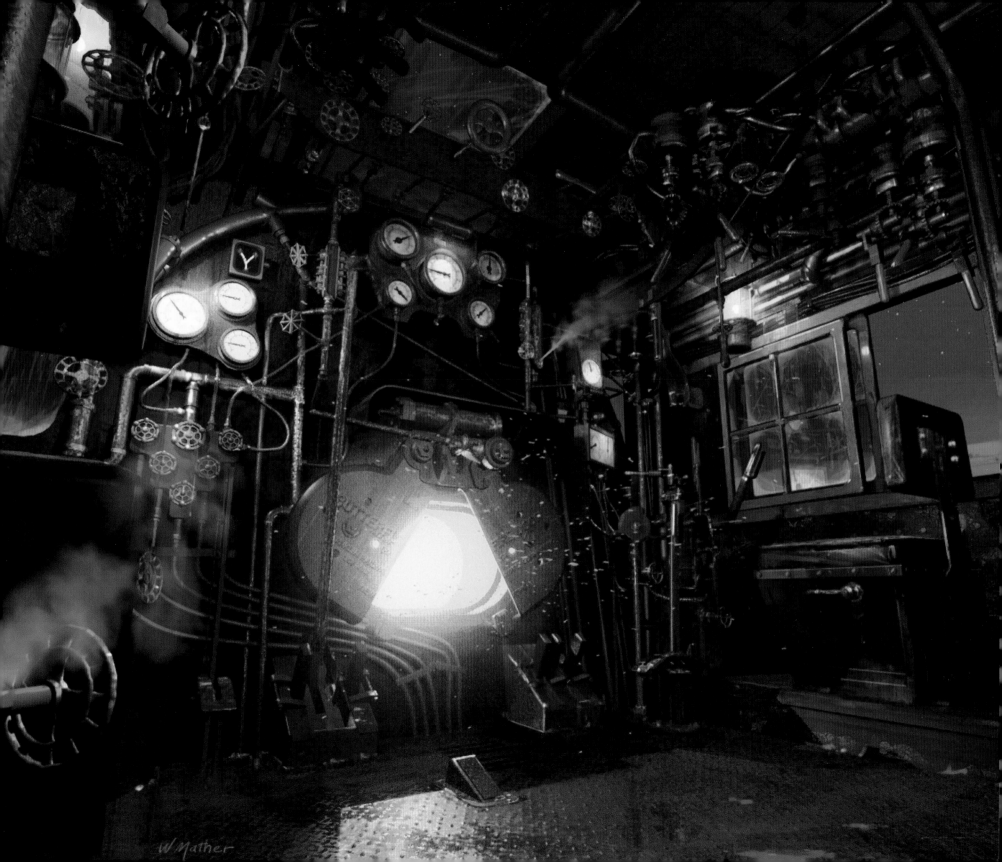

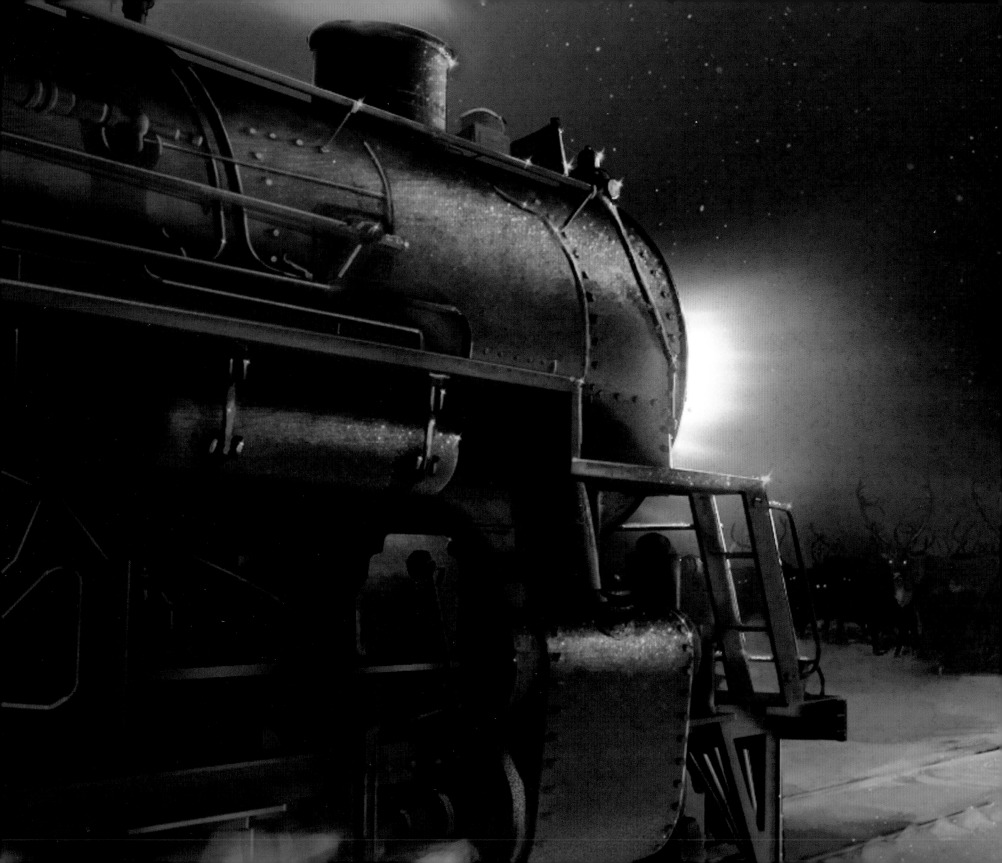

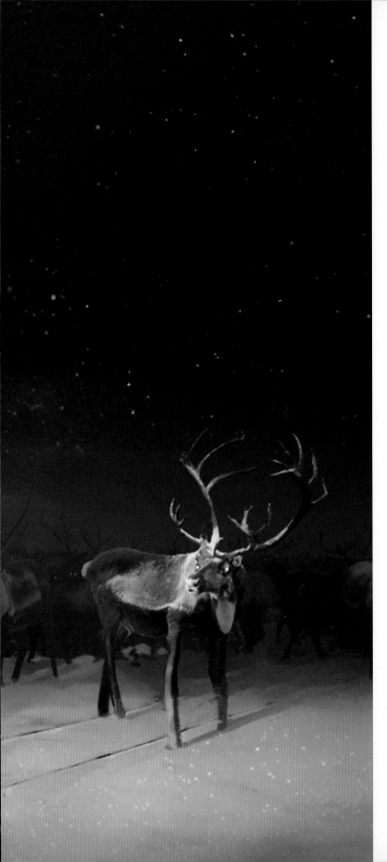

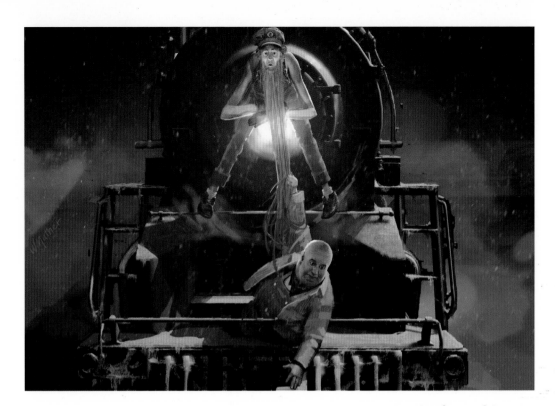

Smokey and Steamer
Bill Mather, August 2003
digital

The first six months I was on the project we [Chiang's unit] locked down how to translate Van Allsburg's palette into a cinematic palette—at that point we brought everybody on board to duplicate that look. At first I had to go in and retouch work and provide a continuity for everyone. But then everyone's work got elevated to the same level. We worked together like a strong family.

—Doug Chiang

Caribou Meeting
Aaron Becker, January 2003
digital

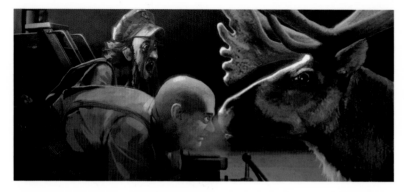

Smokey and Steamer
Bill Mather, March 2003
digital

The movie is about belief, and that's what movies are about—believing. Bob was really making a movie whose theme is referencing the form of the movie medium itself.

—Rick Carter

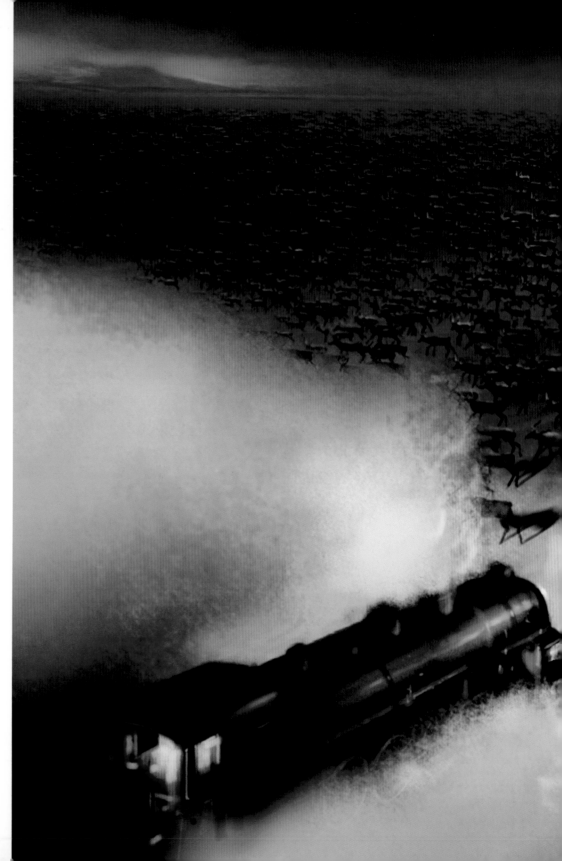

Caribou Herd
James Clyne
November 2002
digital

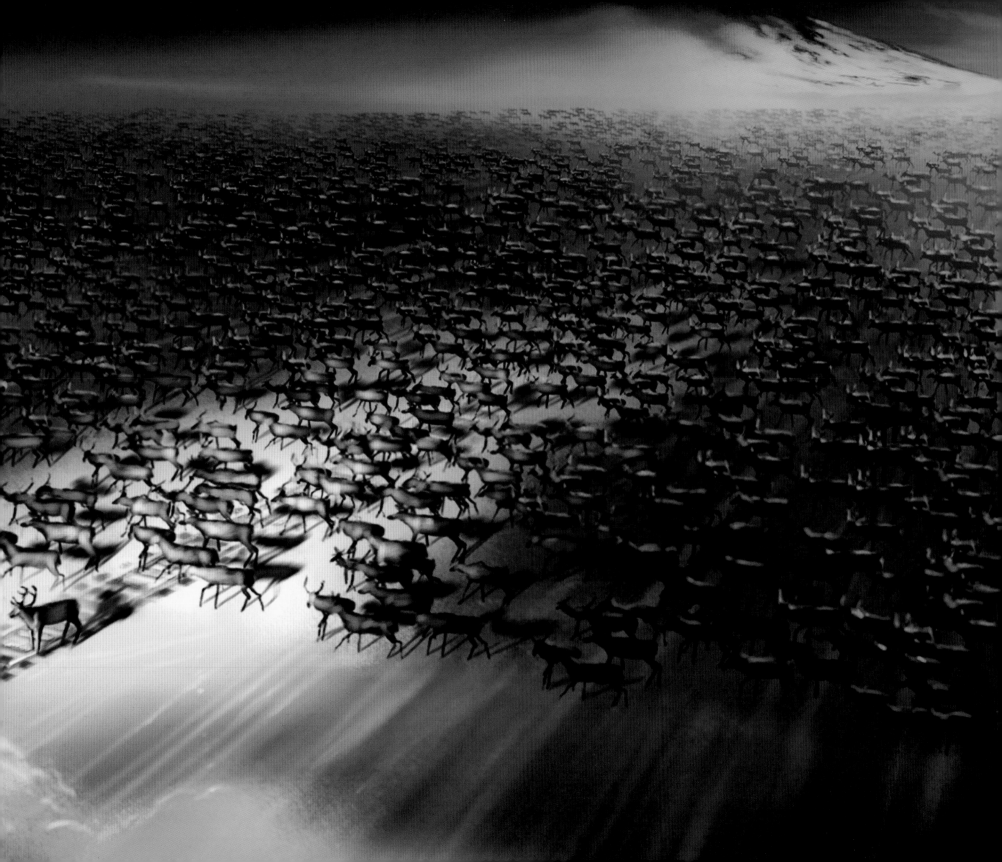

Early P-38 Concept
Doug Chiang, March 2002
digital

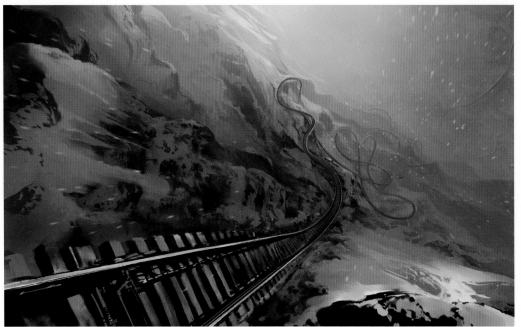

Roller Coaster Path Development
Pete Billington, January 2003
CG digital

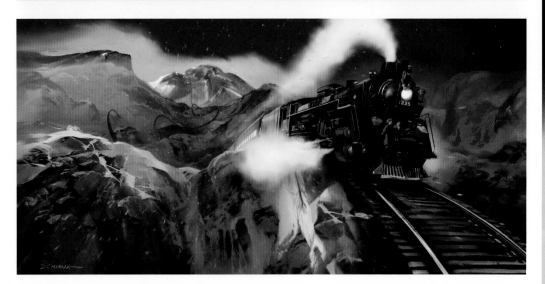

I remember when Bob described a roller-coaster sequence for the train. I started out very conservatively. Here was this gigantic steam engine, so how would you do it? So, I didn't make the hill that the train goes down too steep. When Bob saw it he said, "No, no, no. Think of it as a roller coaster and make it *really* extreme."

—Doug Chiang

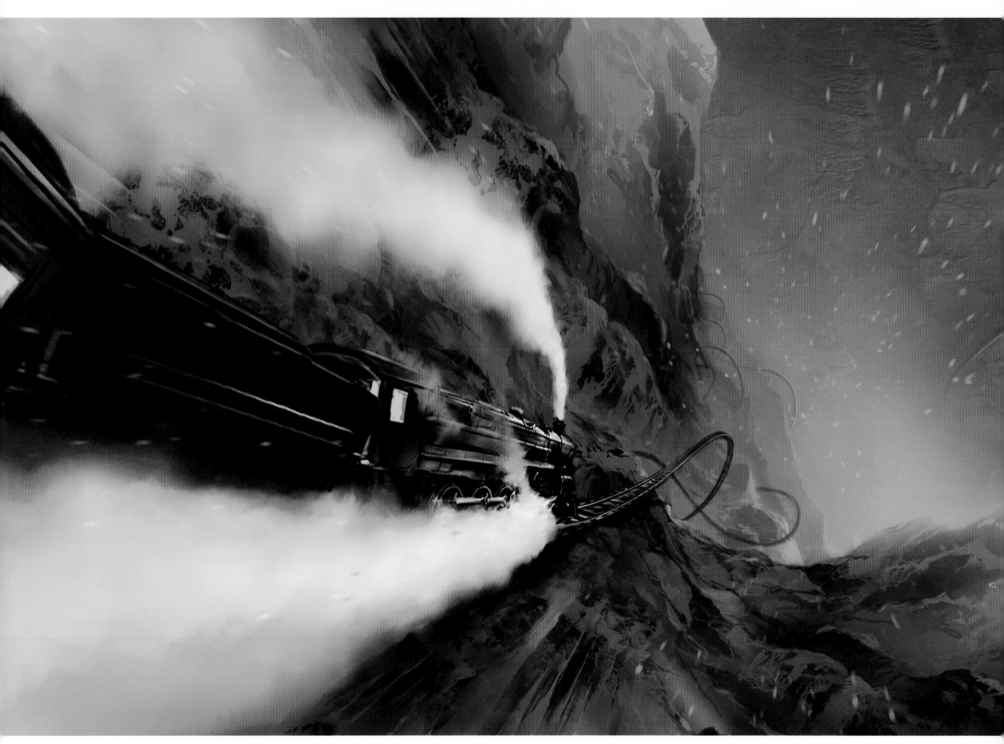

[opposite, center images, and above]

Roller Coaster Development
Doug Chiang, June 2002
digital

Visually, the whole journey to the North Pole could be a dream in the Boy's head. So, why not look at the design of the terrain in terms of how a kid would design the world? I really enjoyed playing around with the look of the glacial terrain, coming up with huge scales that couldn't possibly exist in this world.

—**Doug Chiang**

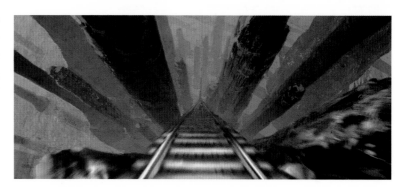

Roller Coaster Buttes
Bill Mather
October 2003
digital

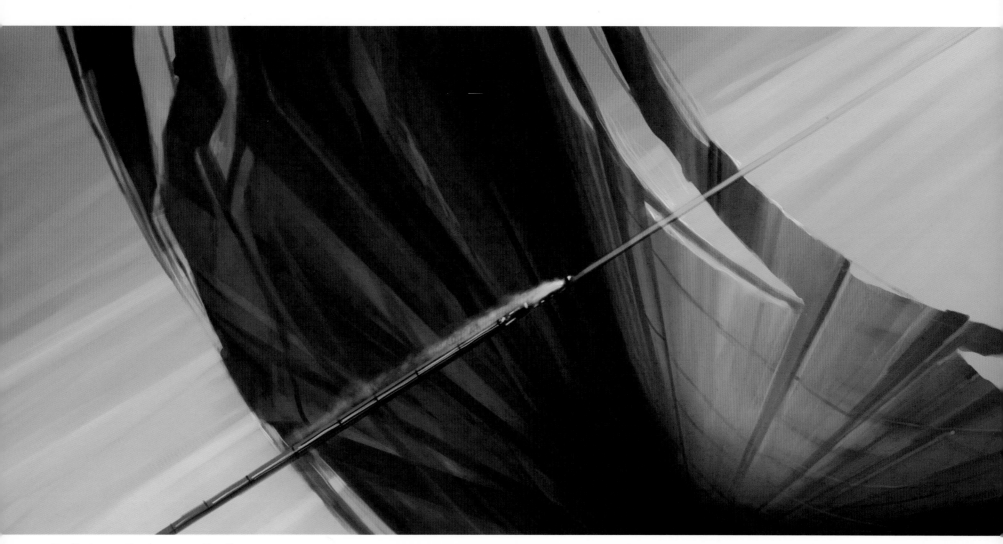

Preliminary Environment Studies
Doug Chiang, May 2002
digital

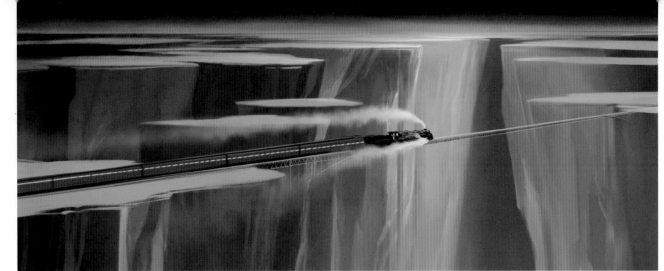

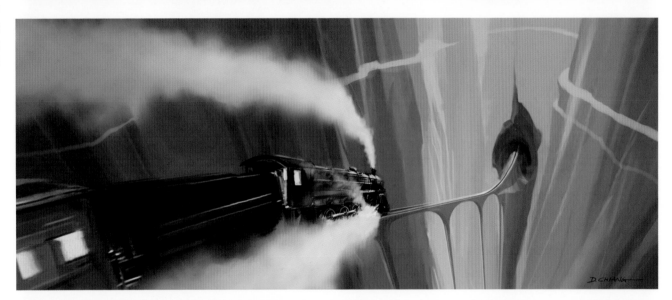

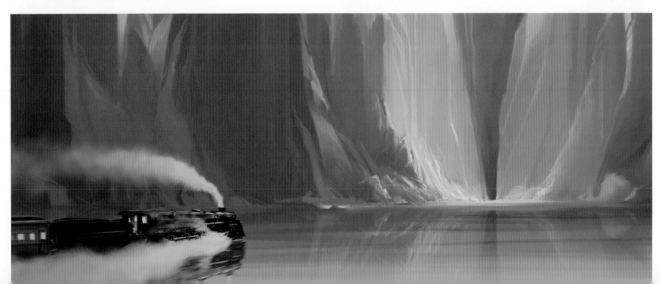

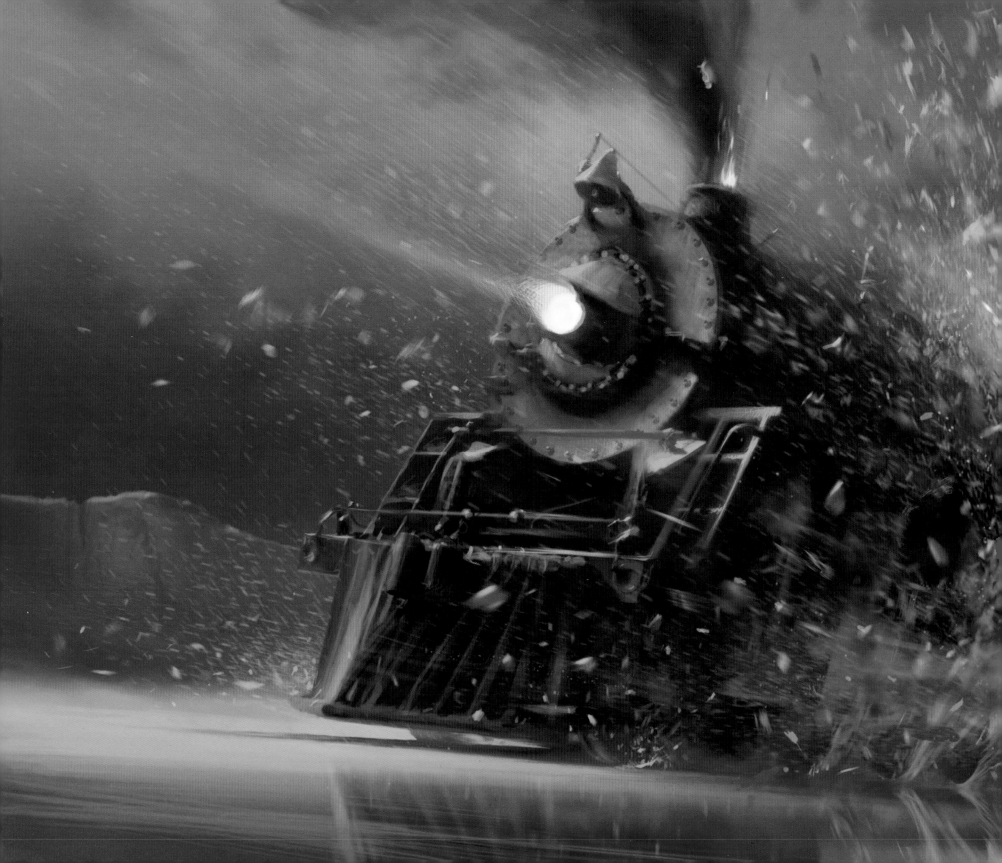

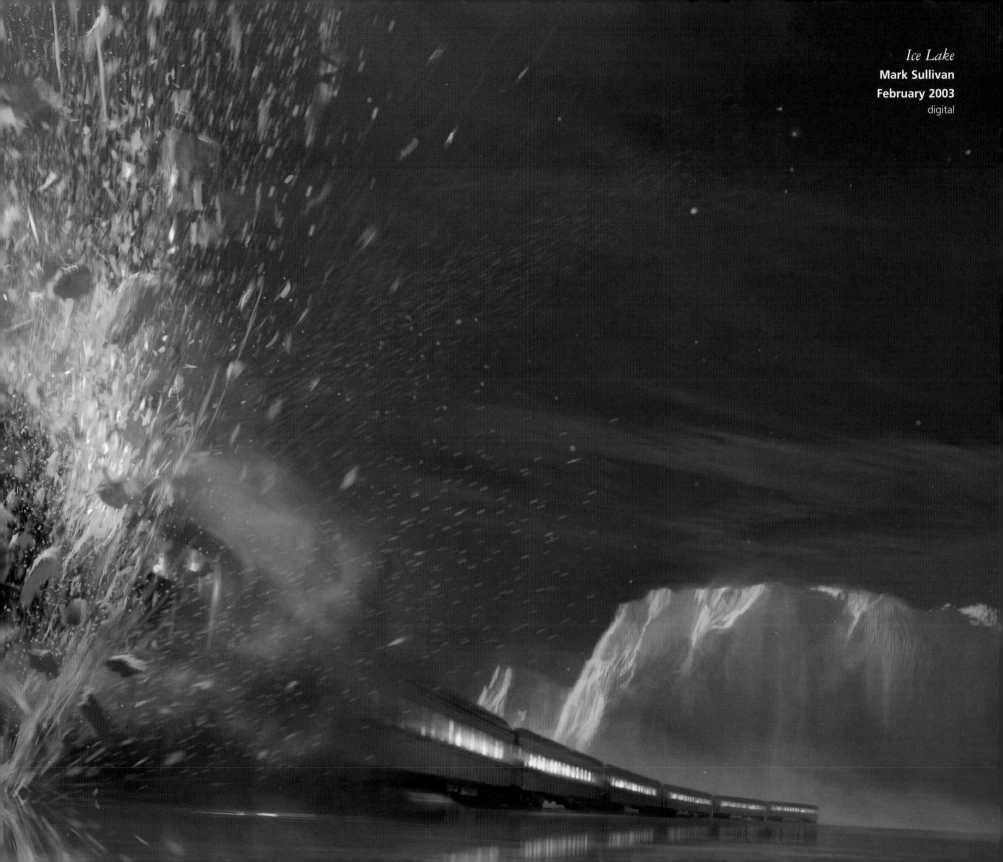

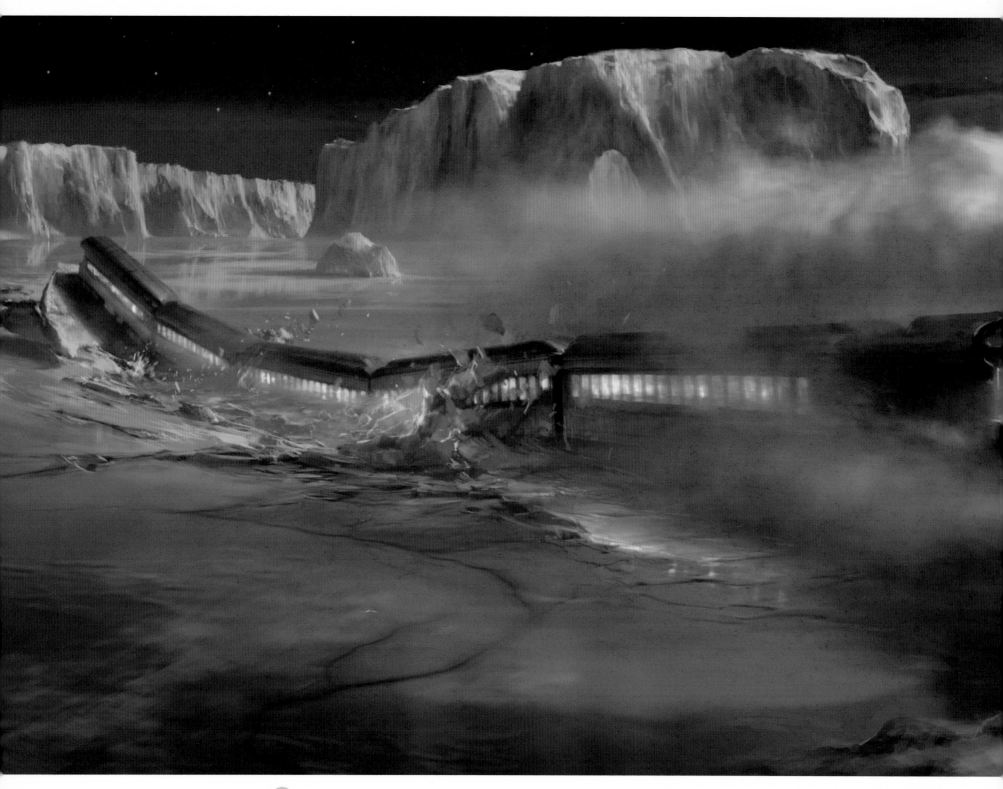

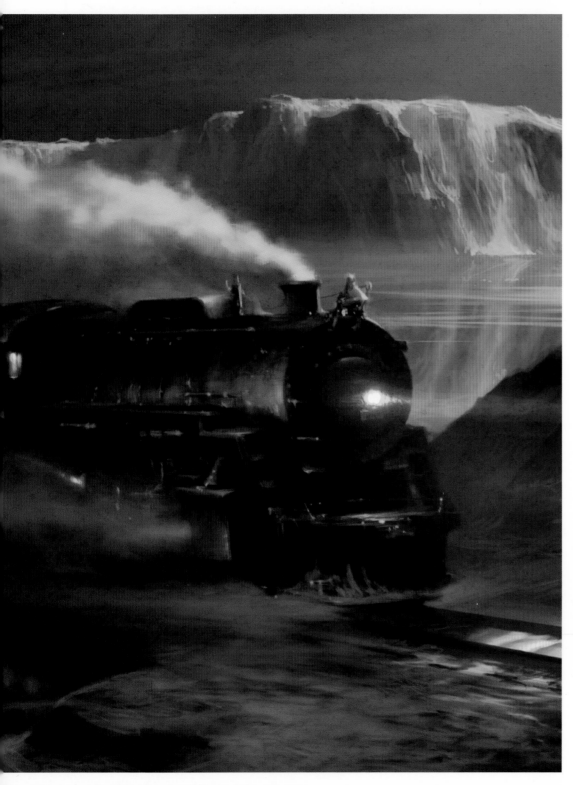

Steve Starkey described the moment that Doug Chiang presented the director with the conceptual art that unlocked the look of the movie: "When Bob saw Doug's images he said, 'If my movie could look like that, I'd be thrilled,'" Starkey recalled. "The artwork wasn't the same tonality and texture as Van Allsburg's paintings, but it evoked the emotional feeling of the book. That was the biggest hurdle, to make that leap from the art form of the book into cinema."

Preliminary Ice Canyon
Doug Chiang, April 2002
digital

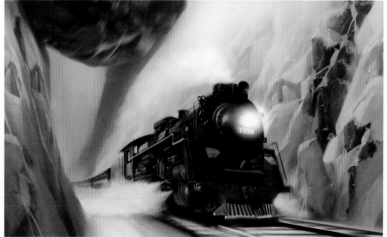

Ice Lake Exit
Mark Sullivan, February 2003
digital

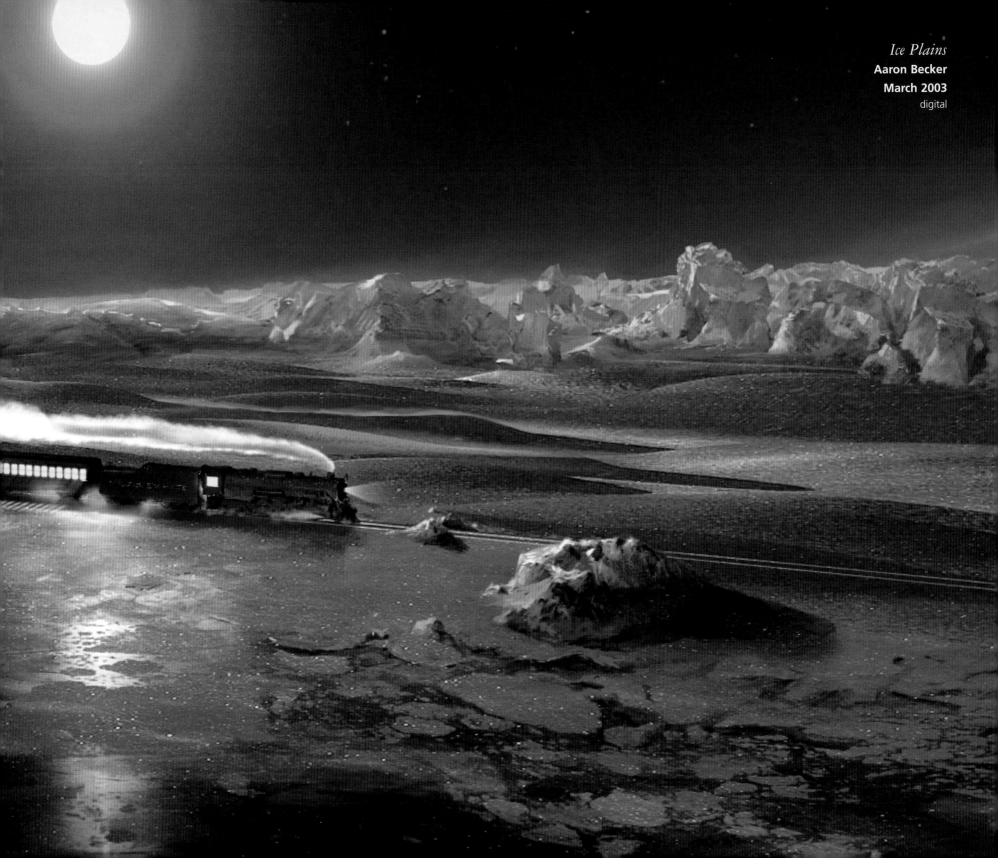

Ice Plains
Aaron Becker
March 2003
digital

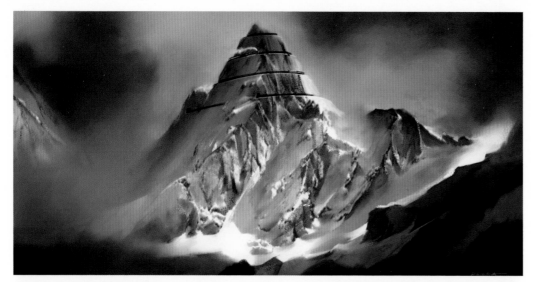

Corkscrew Mountain Development
Doug Chiang
April 2002
digital

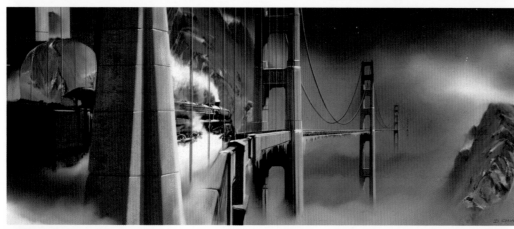

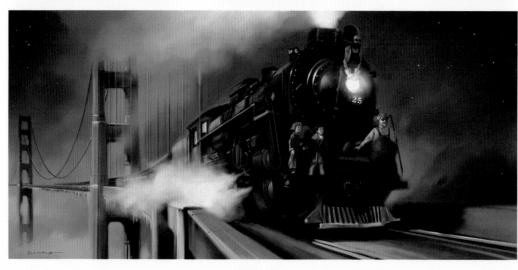

Final Corkscrew Mountain
Mark Sullivan
March 2003
digital

The environments on the way to the North Pole included Corkscrew Mountain, as the filmmakers christened an image, inspired from Van Allsburg's book, of a mountain so high it seemed to practically scrape the moon.

The dramatic rendering of the mountain was inspired directly by a passage in Van Allsburg's book: *Faster and faster we ran along, rolling over peaks and through valleys like a car on a roller coaster.*

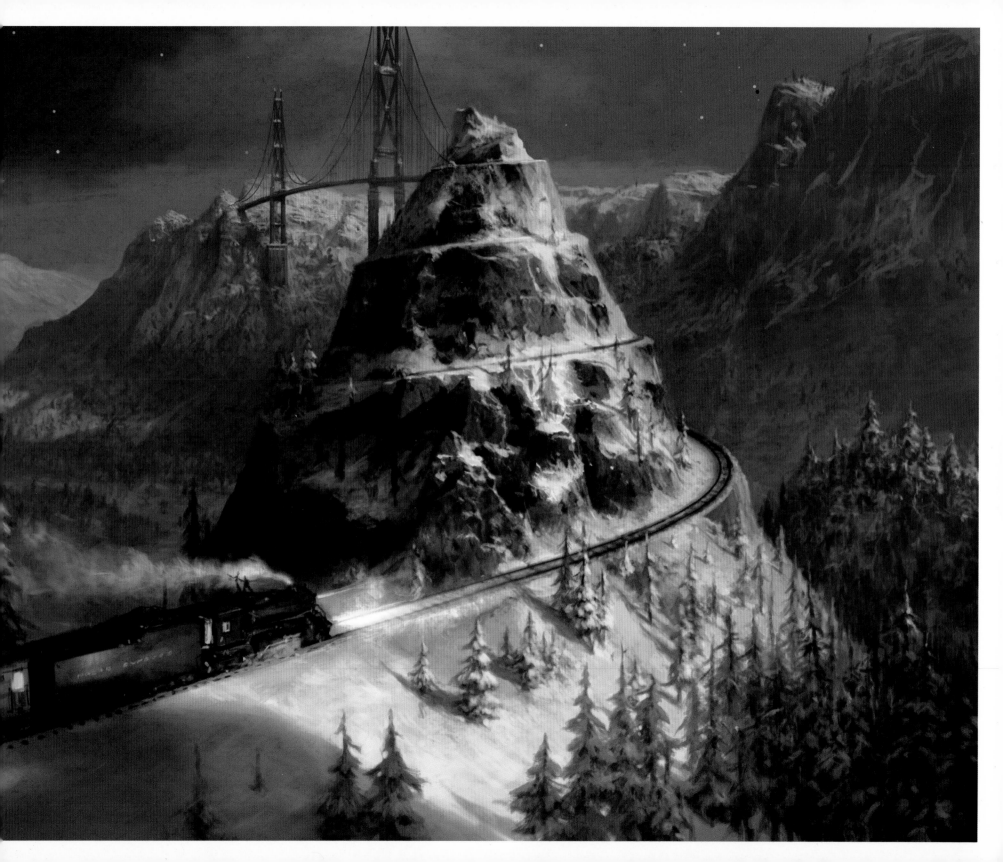

As it went on, the production process was always in a flux of concepts constantly being redone. In a weird way it was as if preproduction stayed through the whole thing, because you could keep changing and manipulating things in a way you could never do with a live-action film. Of course, there are always limitations of time and schedules, but Bob could keep sculpting things until he was happy with them. It was a different way for Bob to work, it was an ongoing invention.

—Ken Ralston

Puppet Car
Randy Gaul and
Zac Wollons
February 2003
digital

Dancer Puppet
Vladimir Todorov
February 2003
digital

Scrooge Puppet
Vladimir Todorov
March 2004
digital

Fox Puppet
Randy Gaul
March 2003
digital

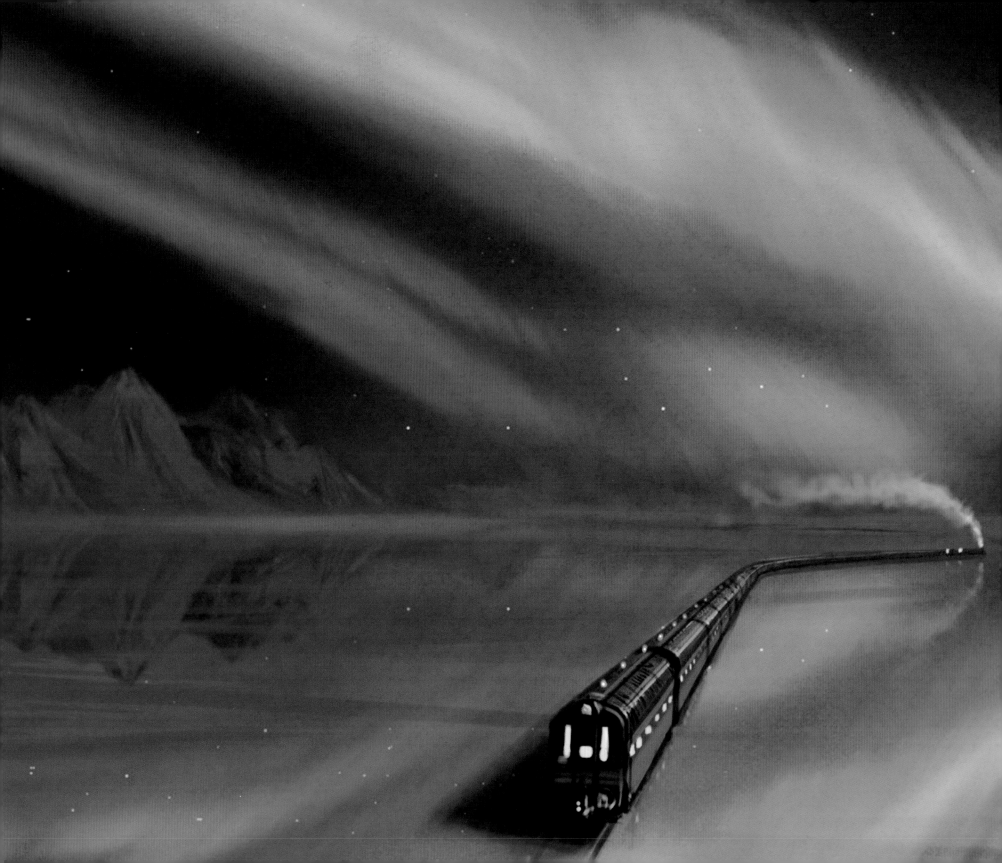

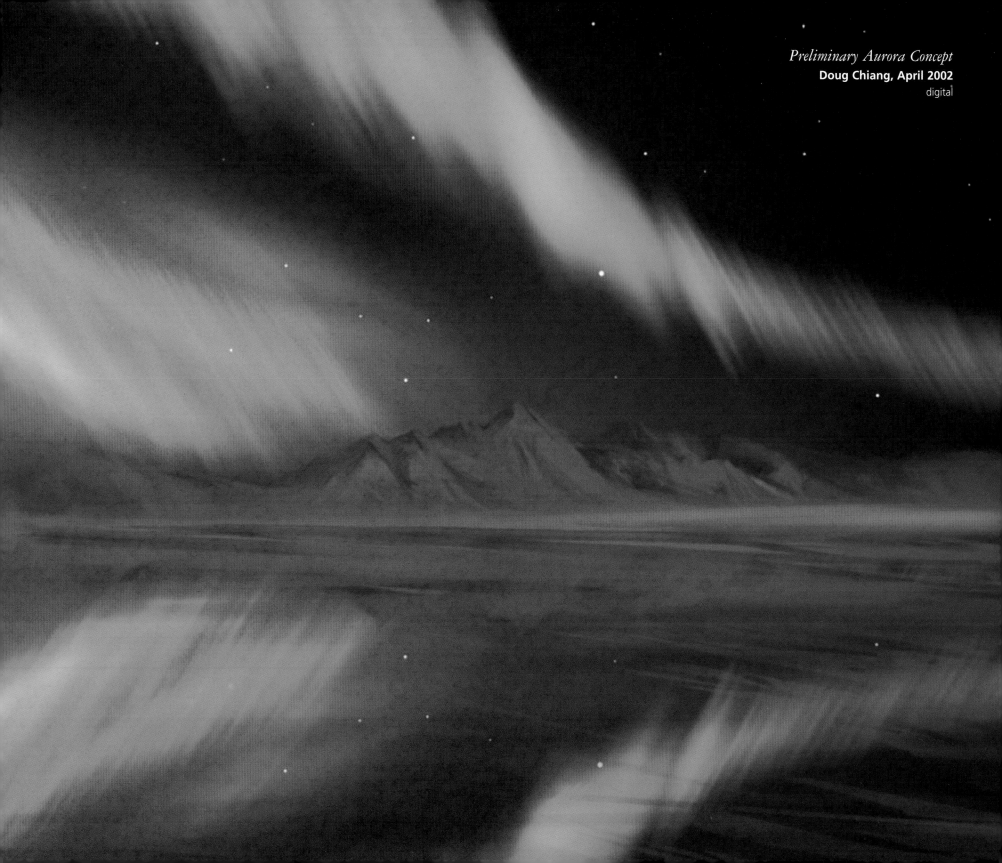

I like to call the visual landscape of a movie the "filmscape," which is the sense of where we go and what happens there and how it feels to be there. Filmscape isn't limited to just what a production designer does, it can be cinematography, visual effects, editing. It's the *space* of the movie, the way you play the movie in your own mind. You can imagine what it'd feel like to walk into these places, independent of narrative or characters and even the movie itself. Imagine Munchkinland in *The Wizard of Oz* or Rick's Place in *Casablanca*—you can put yourself into what it'd feel like to be in those places.

—**Rick Carter**

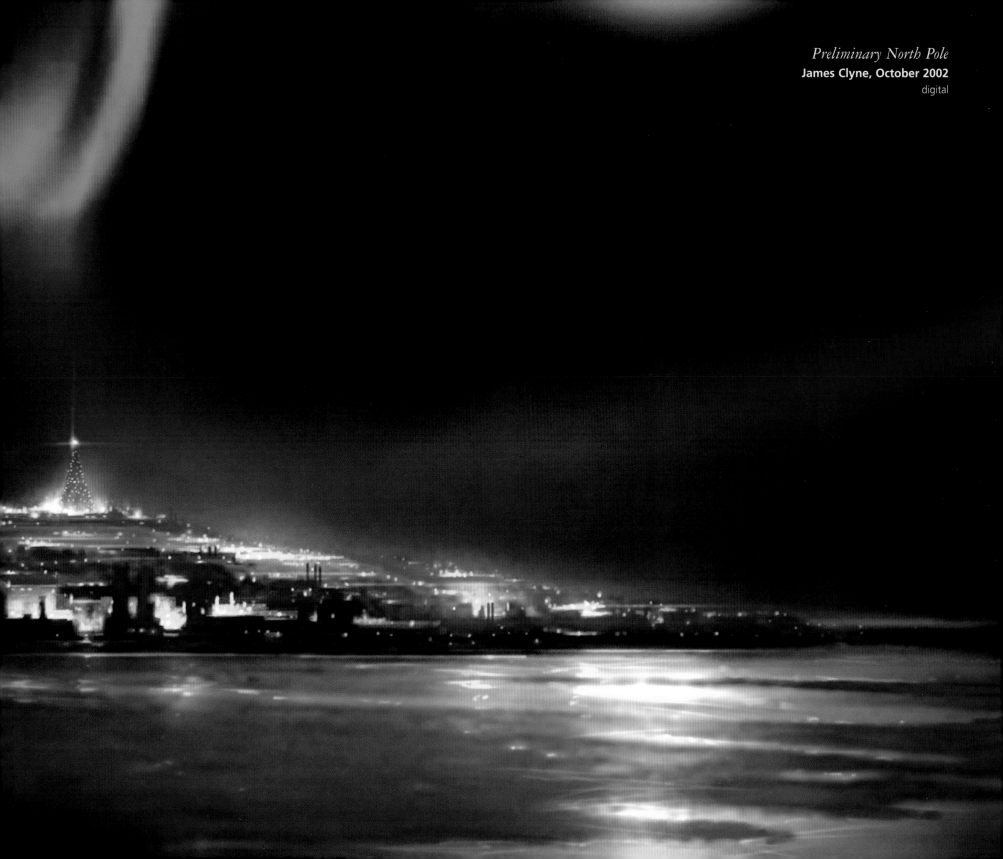

he North Pole. It was a huge city standing alone at the top of the world, filled with factories where every Christmas toy was made. Thus does Chris Van Allsburg describe the arrival of the Polar Express. The children notice the city is strangely deserted, and the Conductor explains all the elves have gathered at the center of the city, where Santa will appear and give the first gift of Christmas to one of the lucky children on the train.

"Right away, the romanticism that some might have associated with the North Pole was taken away by Van Allsburg's images of this industrial landscape," Starkey noted. "That set off an exploration about what exactly the elves were doing—how did this huge enterprise work? How do they build the gifts, wrap them and sort them, bag and ship them?"

The perfect inspiration for the North Pole had been discovered by Rick Carter a mile from Zemeckis's boyhood home: the old Pullman Palace Car Company, which once built sleeping and parlor train cars and where George M. Pullman had a planned town for his workers, an idyllic and orderly community of cottages and gardens.

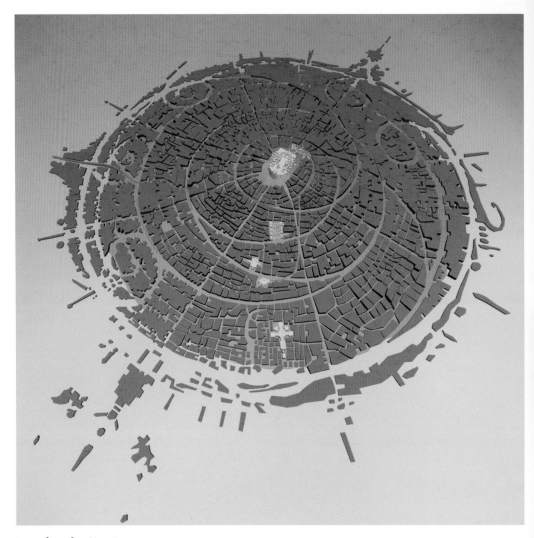

North Pole City Layout
Pete Billington, November 2002
CG model

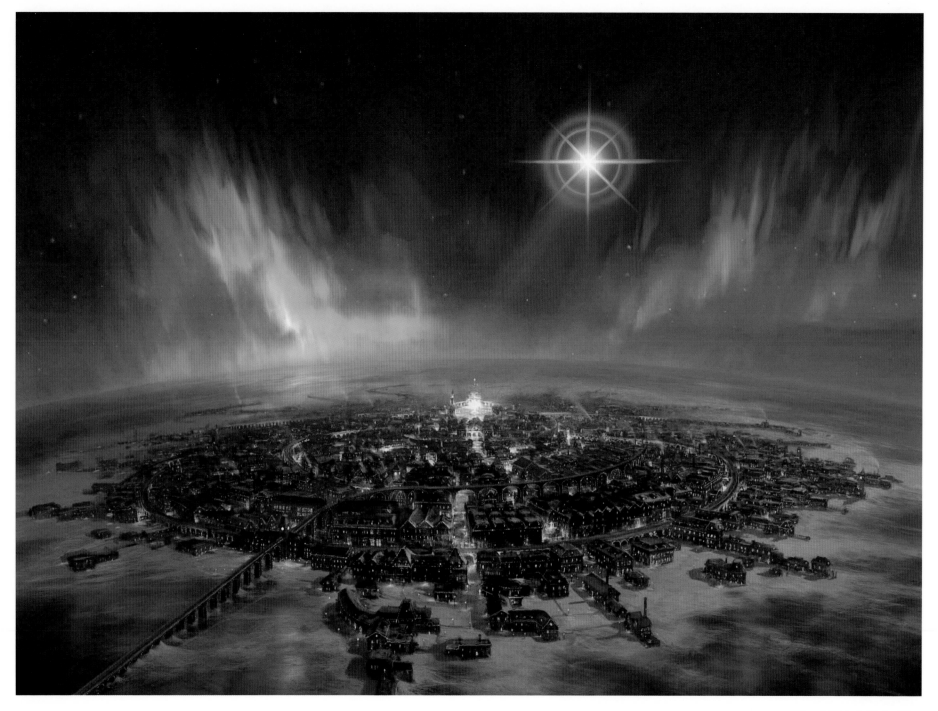

Final North Pole City
Mark Sullivan, January 2004
digital

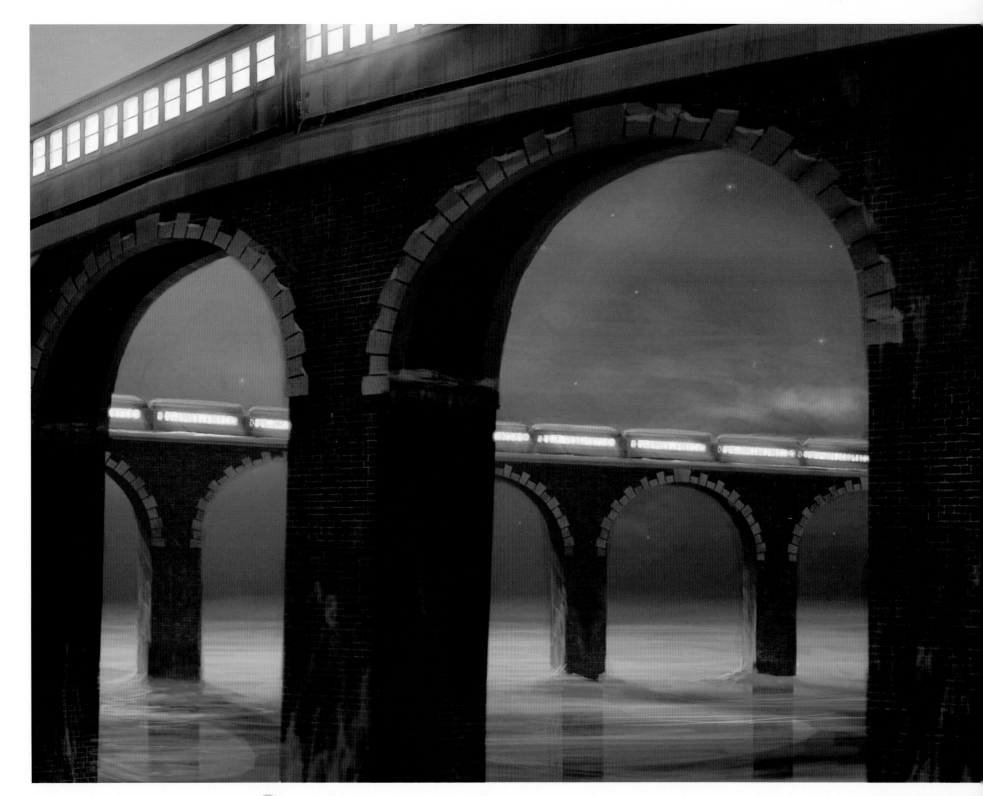

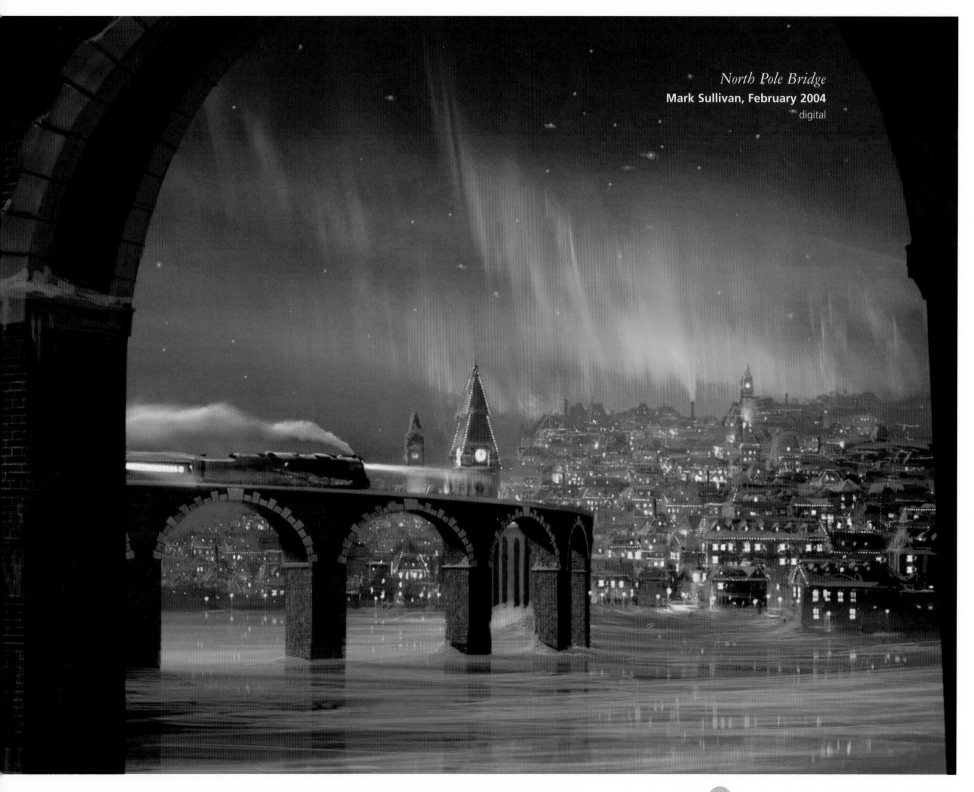

North Pole Bridge
Mark Sullivan, February 2004
digital

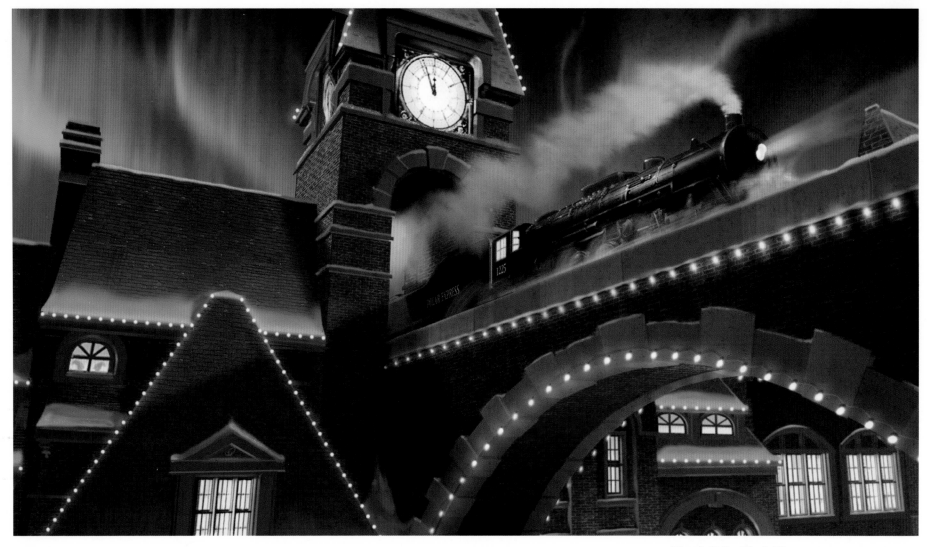

North Pole Clock Tower
Kurt Kaufman, October 2002
digital

The North Pole is a city of industry but it actually looks
like Venice, because it's got canals and is a tiered city.
Doug gave it a more artful sense and charm, although
it's still not the traditional, quaint little Alpine village
with elves working inside little houses.

—Jerome Chen

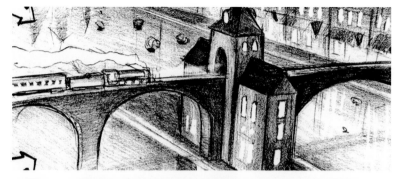

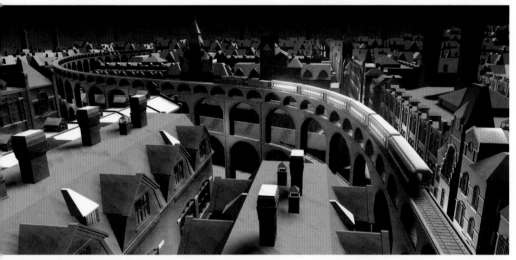

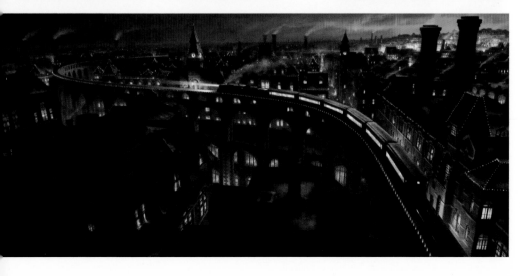

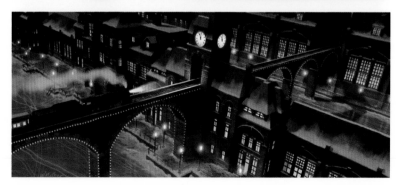

North Pole Entrance Sequence
Stefan Dechant (Storyboards)
Young Duk Cho (CG Models)
Mark Sullivan and Bill Mather (Paintings)
October 2002

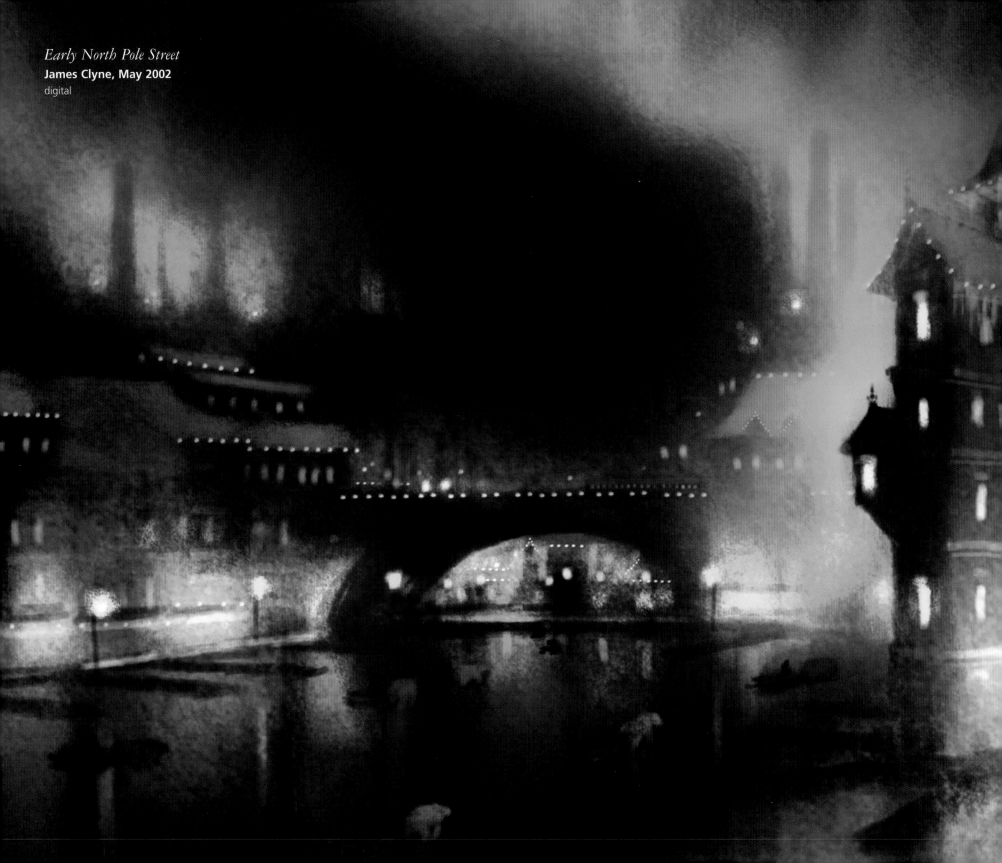

Early North Pole Street
James Clyne, May 2002
digital

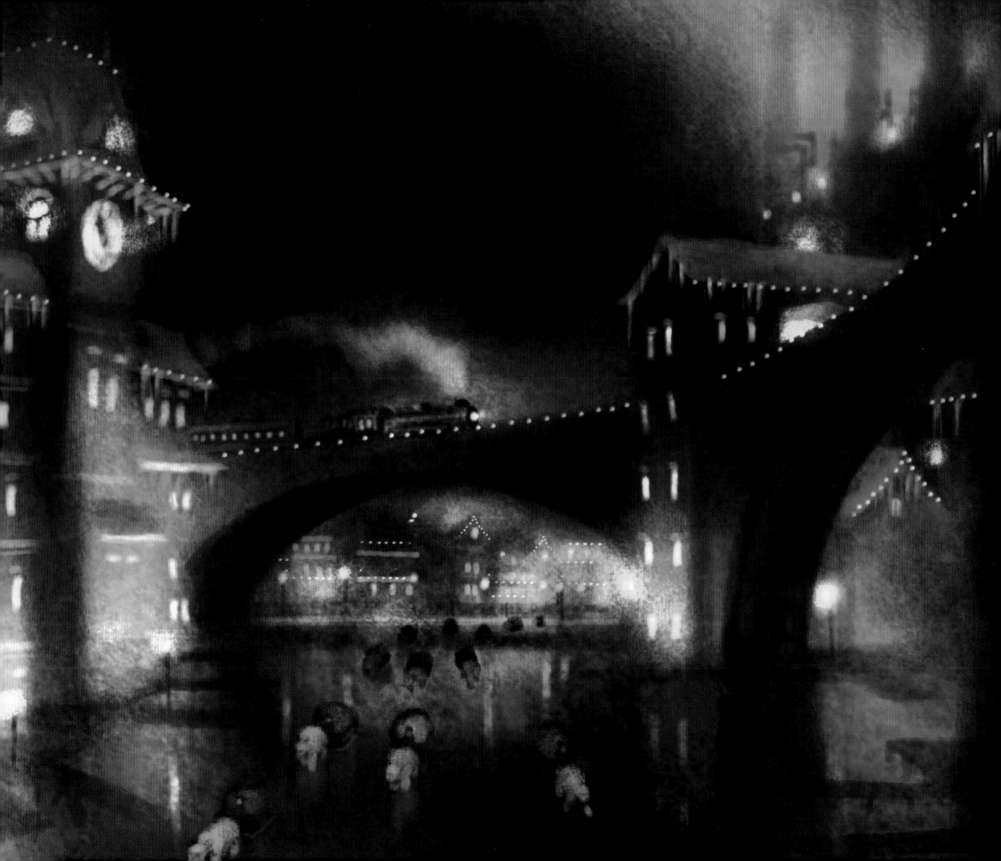

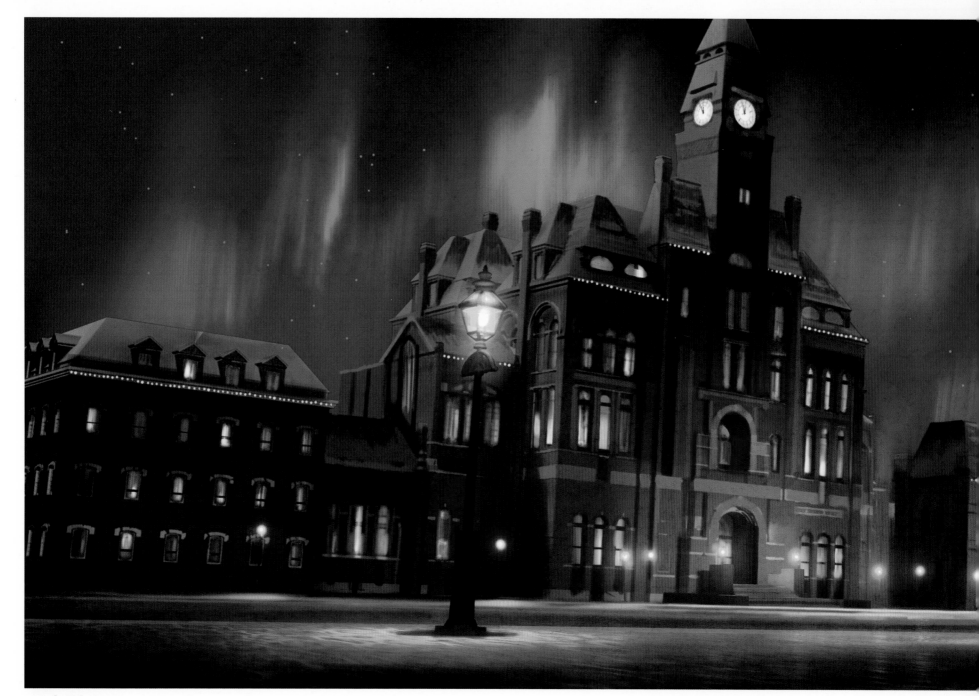

North Pole Square
Brian Flora and Young Duk Cho
November 2002
digital

The Pullman Factory and hotel in the South Side of Chicago used as reference for the North Pole Square

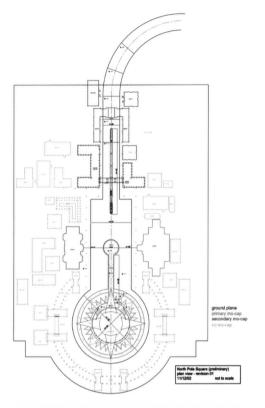

North Pole Square
Northern California
Art Team
2003
CAD drawing

The North Pole is a factory-type community with elves dedicated to making toys. We kept the idea of this community experience in mind as we began designing the North Pole. It also helped to have a sense of logic to the place when the train first approaches the North Pole—we go through the industrial part, the residential section, and finally the Square, where all the elves are gathering. The design was about building and reinforcing the experience, to have a sense of logic to this community.

—Doug Chiang

North Pole Square
Zac Wollons and Young Duk Cho
October 2002
CG model

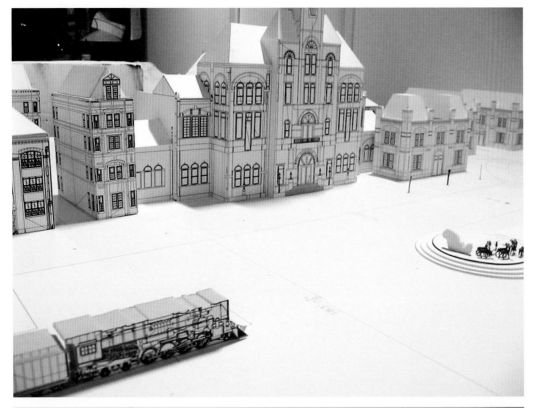

*North Pole Square
Model*
December 2002

*Entrance to North
Pole Square Model*
December 2002

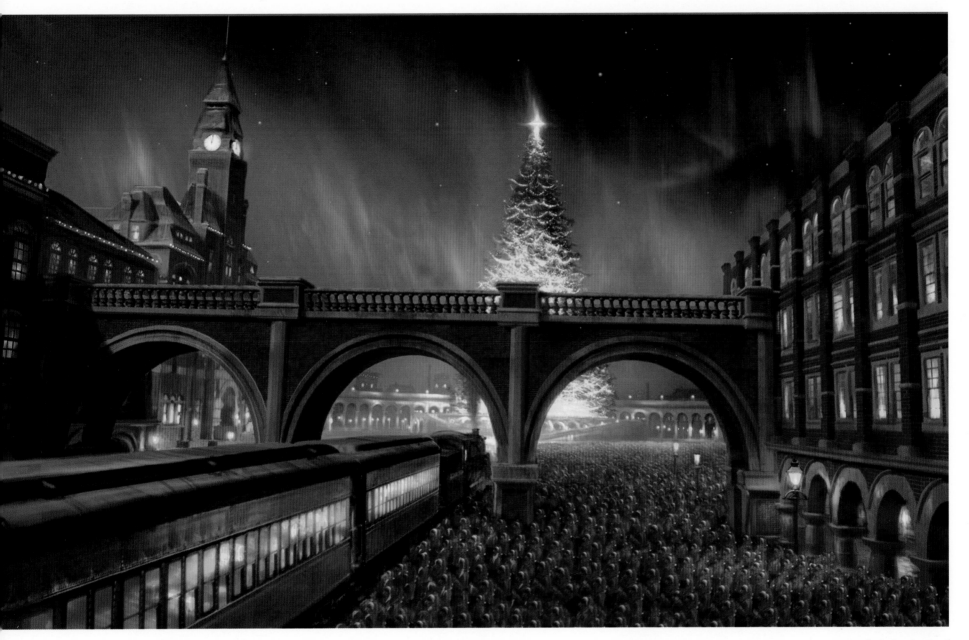

There was a color palette developed for the whole movie. In the beginning it was more of a monochromatic blue and green. It's as we hit the North Pole that the clouds start lifting and the full palette of emotions starts coming back into the story in terms of bright, Christmasy color and light.

—Steve Starkey

North Pole Arrival
Mark Sullivan and Young Duk Cho
November 2002
digital

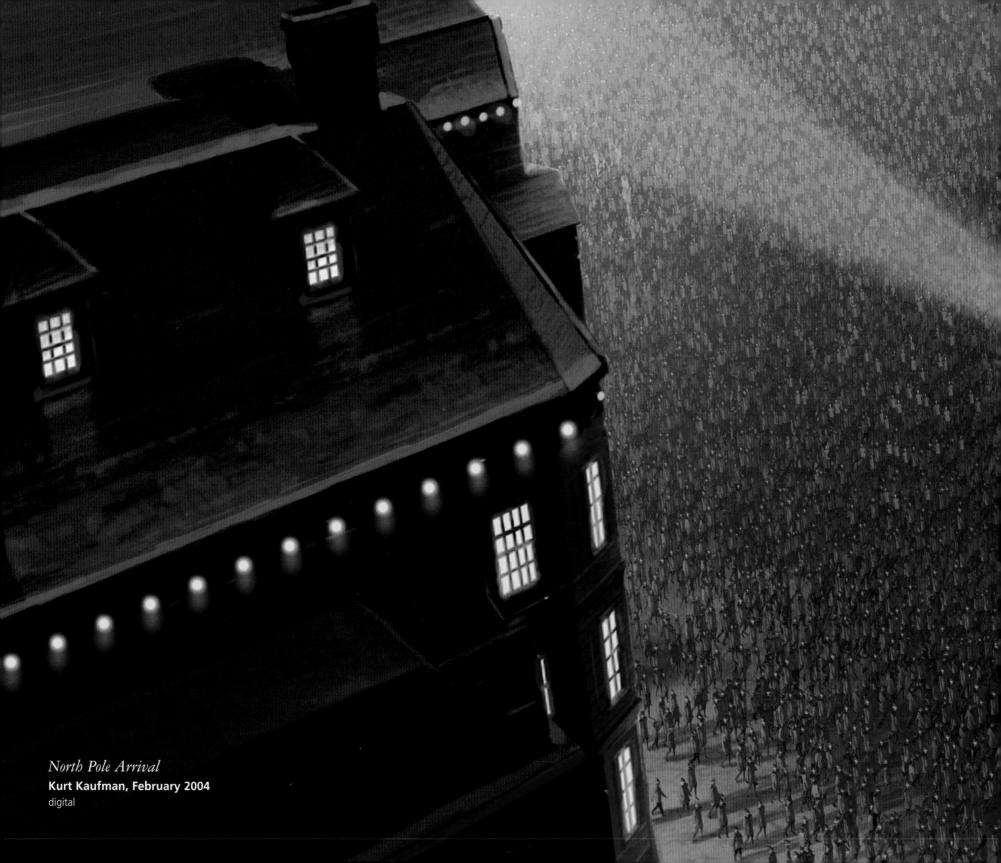

North Pole Arrival
Kurt Kaufman, February 2004
digital

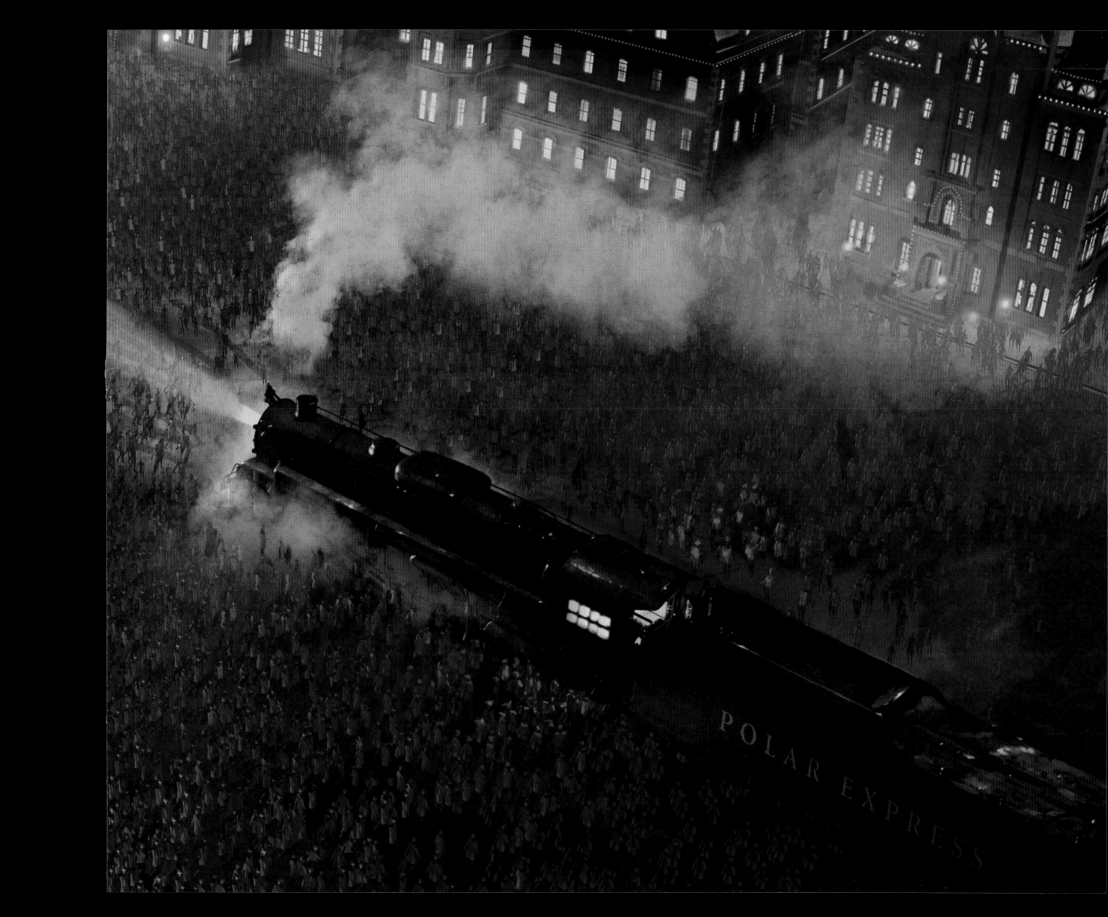

Toy Tractor
**Randy Gaul,
Pete Billington, and
Zac Wollons
February 2003**
digital and CG model

s the train pulls into the main square, the car with our hero children has fallen away
from the train and is on the fast track to the other side of town. The muse storytellers
hear—like the ringing sleigh bell of the Polar Express—can lead both creators and their
creations along peculiar and circuitous paths. One such jaunt developed the notion of
elves playing vinyl LP Christmas albums on old-fashioned turntables and piping the music into the air.
But the idea began with the Boy, Girl, and Lonely Boy searching the deserted factory district for a way
back to the Square. The Girl and Lonely Boy are drawn by the beguiling ring of a sleigh bell, but the
Boy, struggling with doubt, doesn't hear it. "There was a big debate about how to cue the audience in
without having them actually hear the bell," Jerome Chen recalls. "Bob came up with the idea of this
area that was like an empty shopping mall with Christmas music from the 1950s continually playing,

echoing through this vast space. Then, whenever the record skips, that's the subliminal cue to the audience that the Girl and Lonely Boy are hearing the bell.

"What then came up was that most kids today don't have vinyl records, so how are they going to know what a skip is? So we had to have a shot of a huge room with all these record players and a closeup of a record playing where you see the needle skipping. So the vinyl record became the technique for revealing that you can only hear the bell if you believe and the Boy only hears the record skipping because he's losing his belief. The reason for everything in this movie had that kind of depth to it."

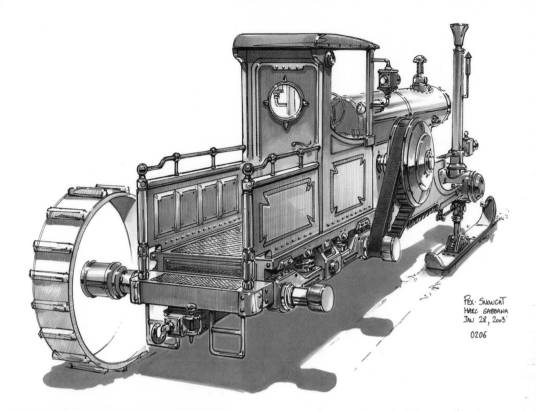

Toy Tractor Design
Marc Gabbana
January 2003
pen and marker

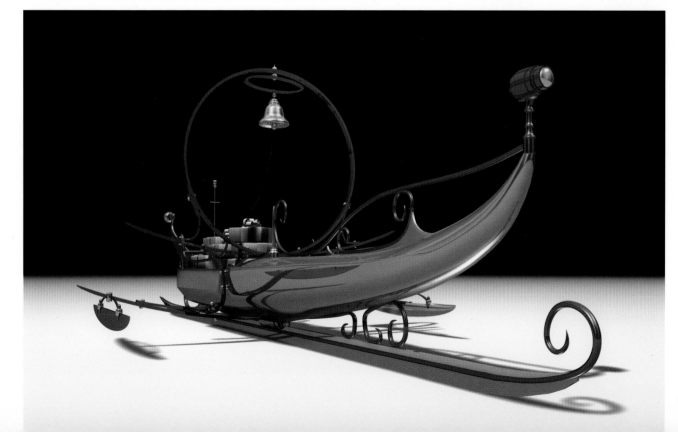

Ice Gondola
Matthew A. Ward
December 2002
CG model

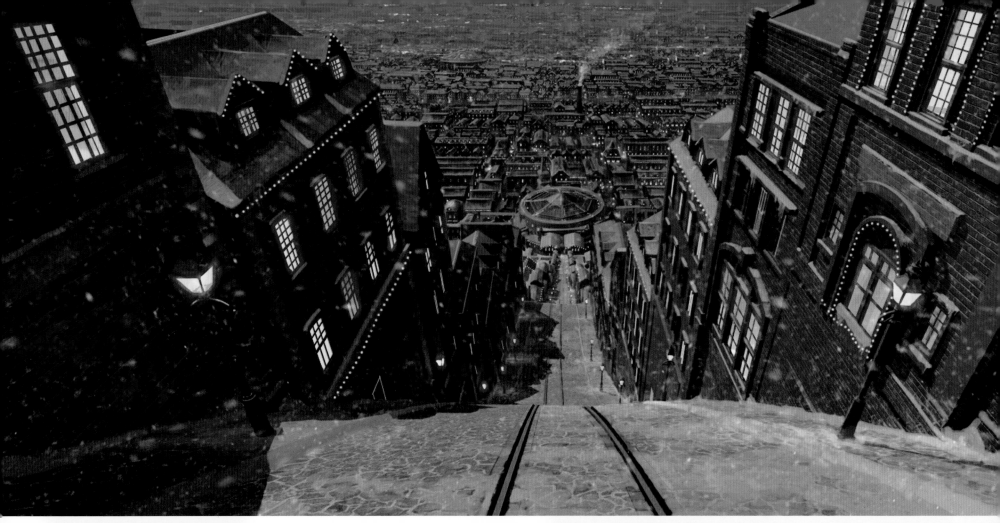

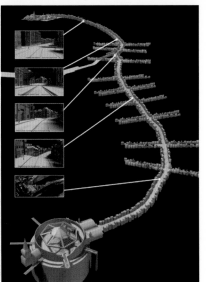

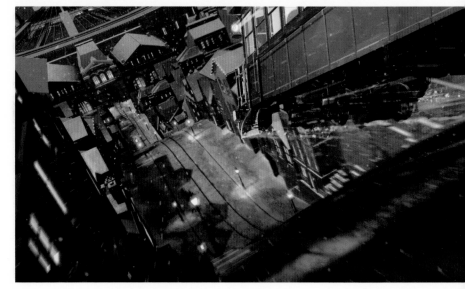

Point of View of Runaway Car
Bill Mather and Zac Wollons
January 2003
digital

Runaway Car Layout
December 2002

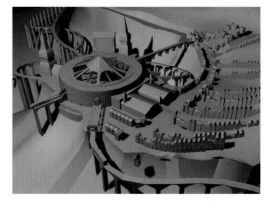

Roundhouse District Model
Zac Wollons, October 2002
CG model

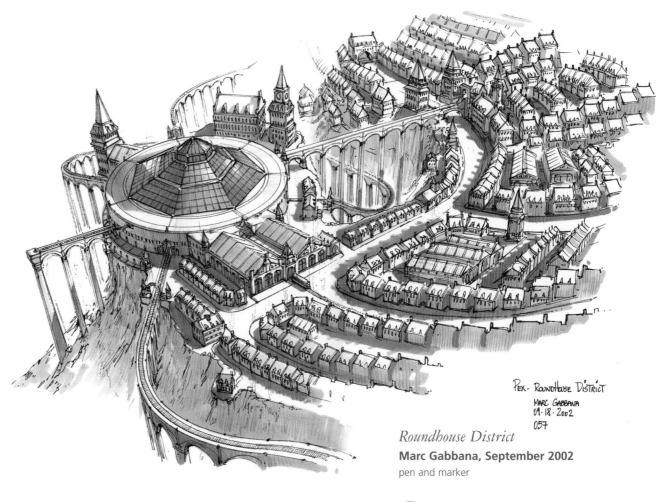

Pex- Roundhouse District
Marc Gabbana
09·18·2002
057

Roundhouse District
Marc Gabbana, September 2002
pen and marker

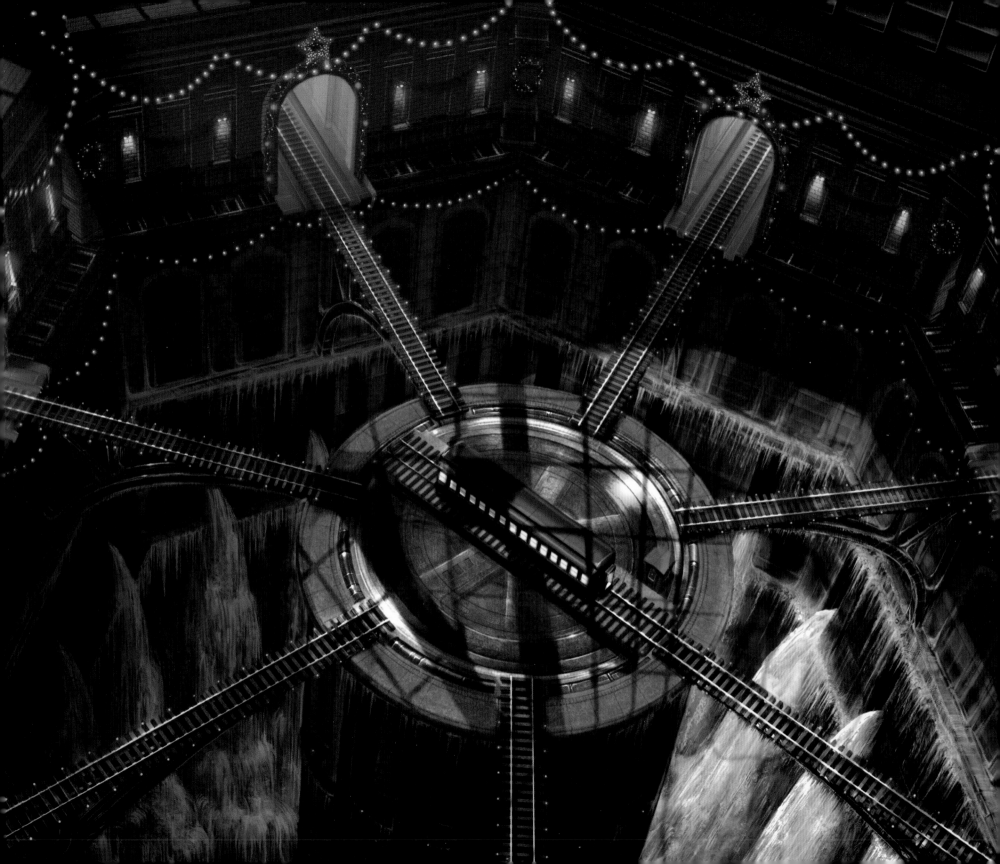

[opposite]
*Roundhouse
Interior Falls*
**Randy Gaul
November 2002**
digital

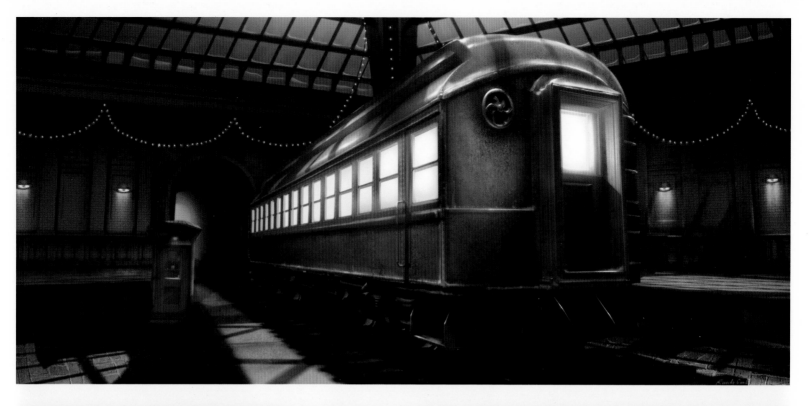

Roundhouse Interior
**Randy Gaul and
Bill Mather
September 2002**
digital

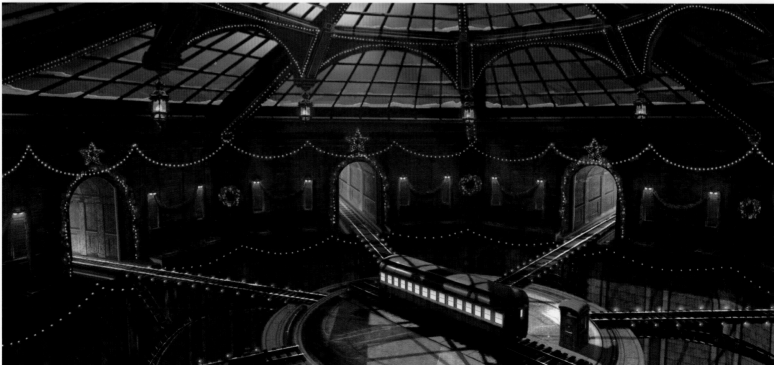

Elf Street Storyboard
Simon Wells
June 2002
pencil

Elf Town Street
Zac Wollons
October 2002
CG model

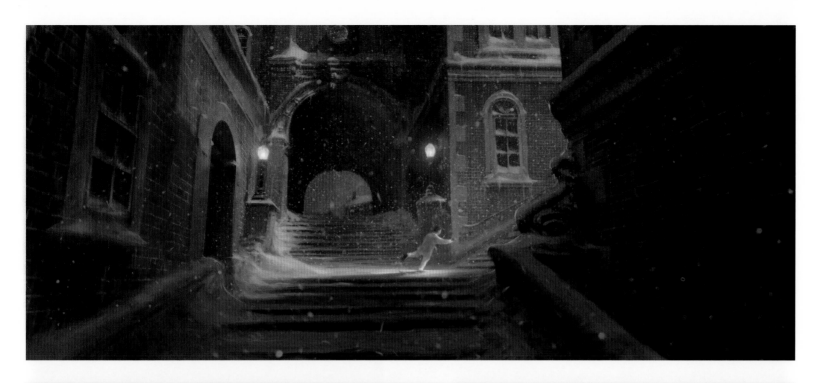

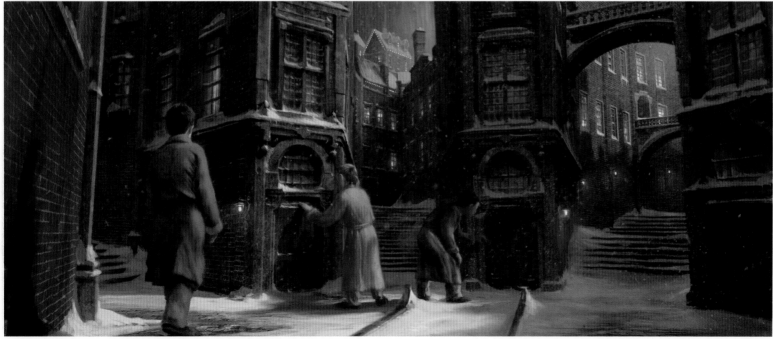

*Children Exploring
Elf-Scale Back
Alley Streets*
Mark Sullivan
January 2003
digital

107

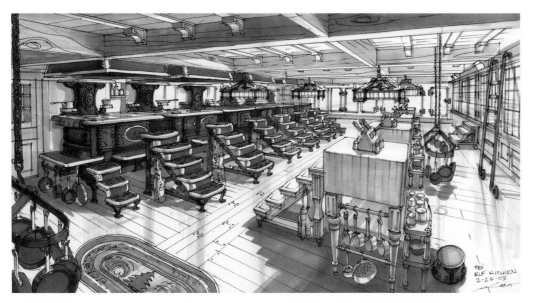

Elf Kitchen
Kurt Kaufman, March 2003
pen and marker

Elf Bar
Marc Gabbana, March 2003
pen and marker

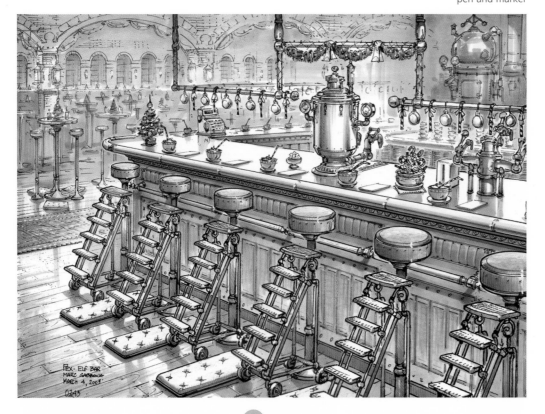

Dead-End Street
**Kurt Kaufman and
Zac Wollons
November 2002**
digital

One of the fun elements of designing the North Pole was trying to imagine how the elves lived. In many cases, the only appliances available were on a human scale.

—Steve Starkey

Elf Bathroom
**Randy Gaul and
Pete Billington
March 2003**
digital and CG model

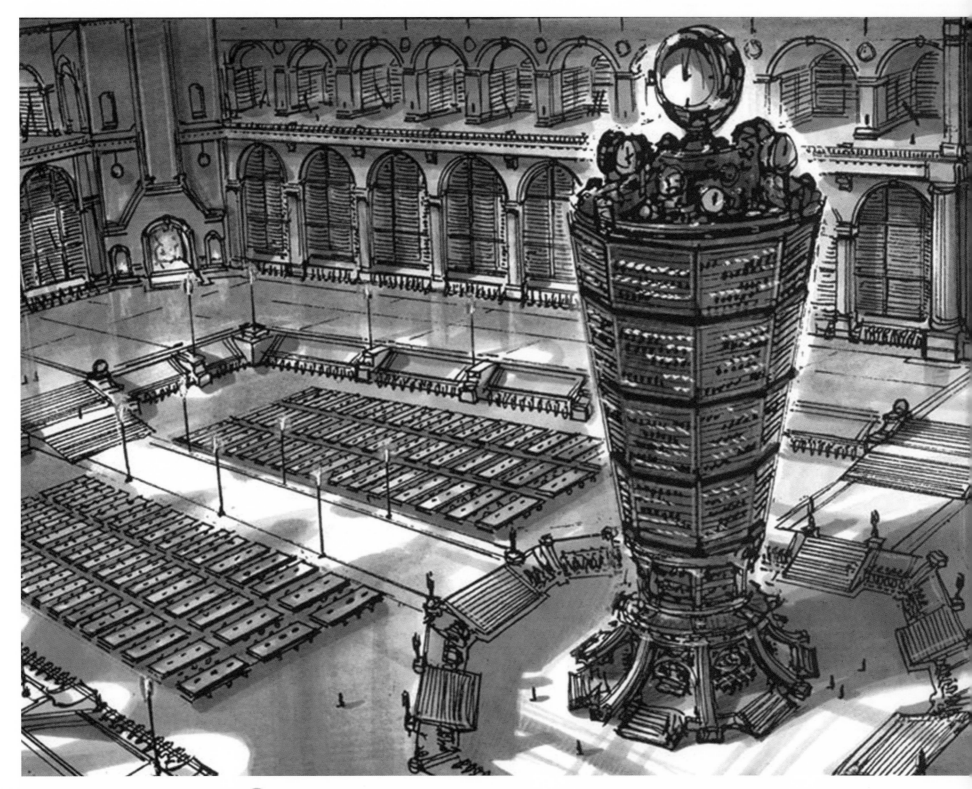

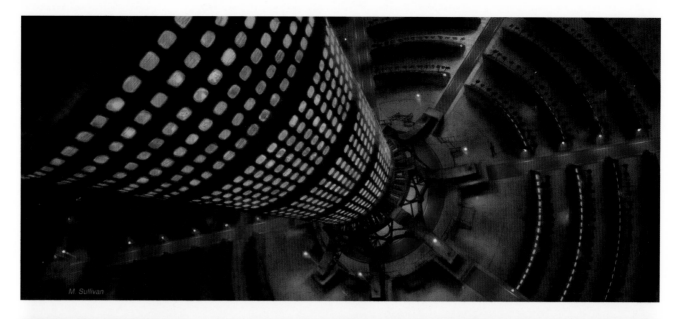

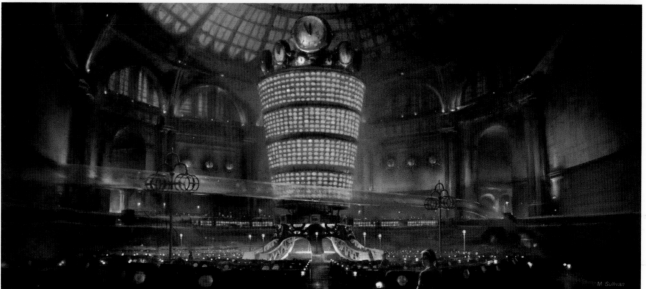

Surveillance Room Developments
Mark Sullivan, July 2002
digital

Surveillance Room Design
Marc Gabbana, July 2002
pen and marker

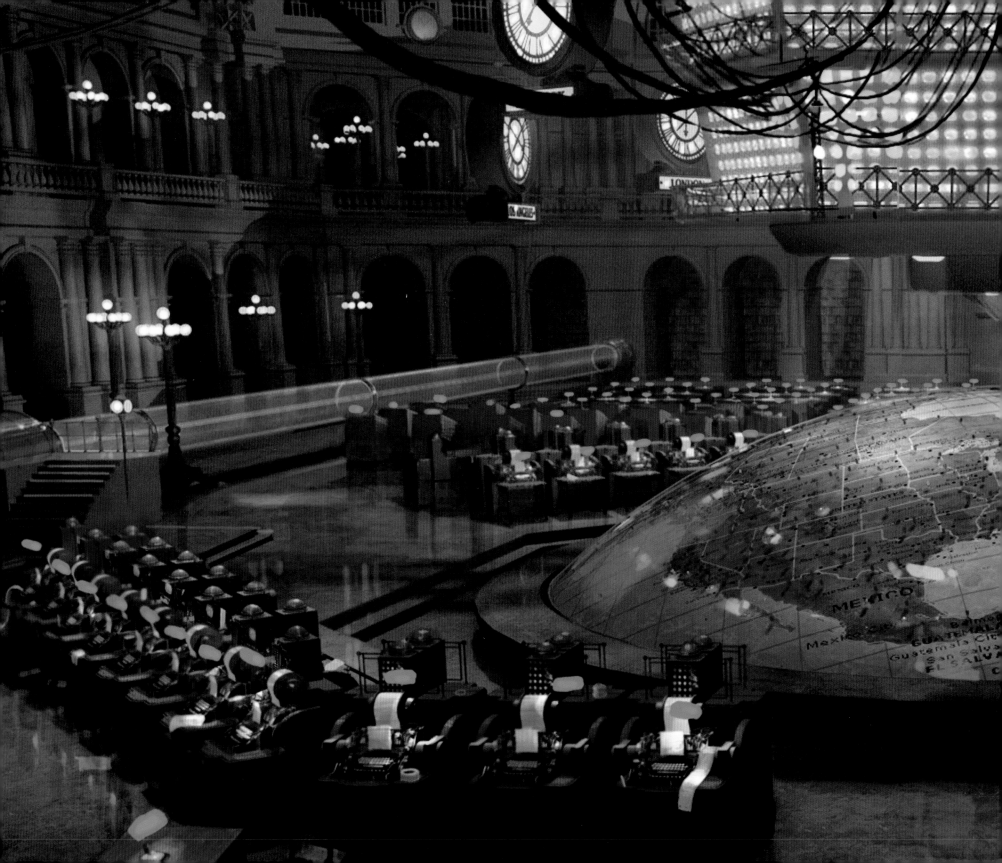

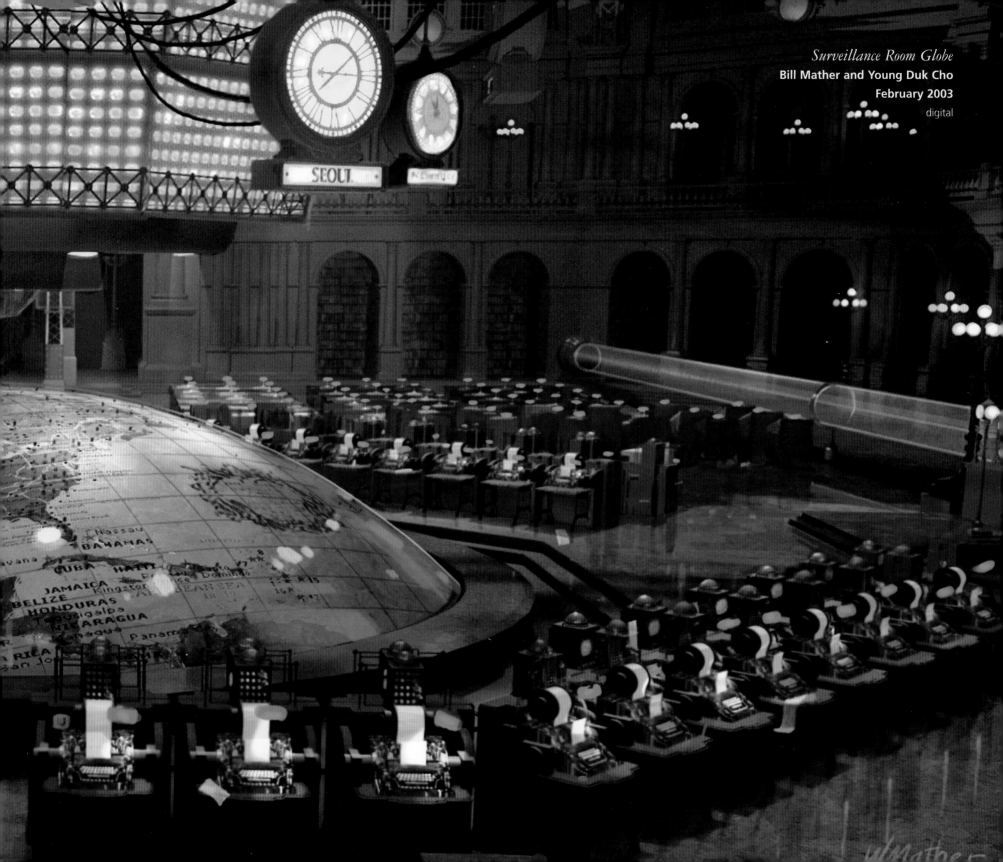

Surveillance Room Globe
Bill Mather and Young Duk Cho
February 2003
digital

In some respects, we went high-tech at the North Pole, although it's the kind of technology that never advanced past the 1950s. For example, the elves still play vinyl LP records. There's a point in the film where the Boy, Girl, and Lonely Boy are in a car that gets separated from the rest of the train and rolls off the beaten track. The little switch track that sets this off looks like something an elf would build; it's a bigger, more efficient version of a toy.

—**Jerome Chen**

Surveillance Room
Mark Sullivan
September 2002
digital

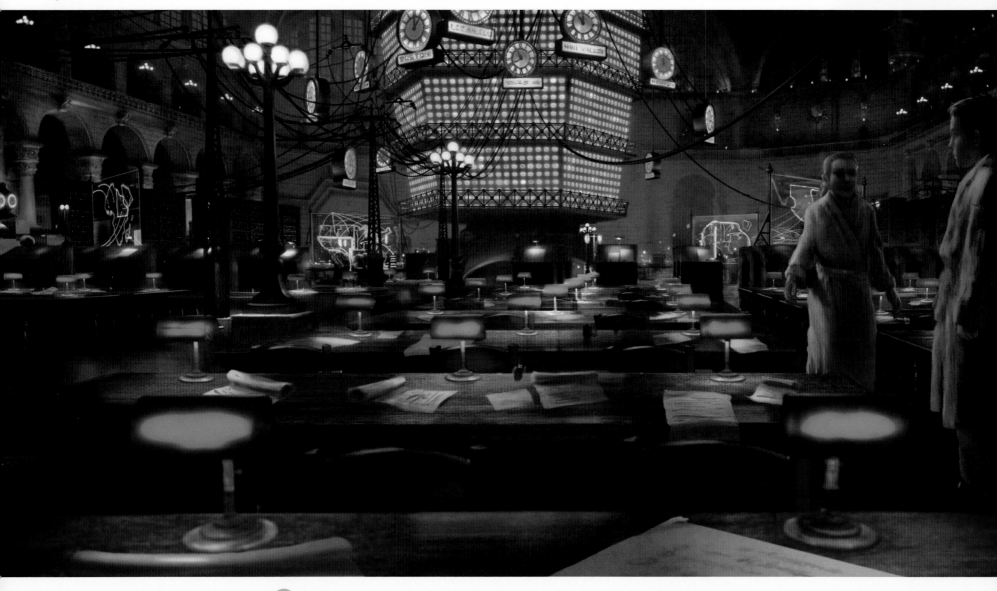

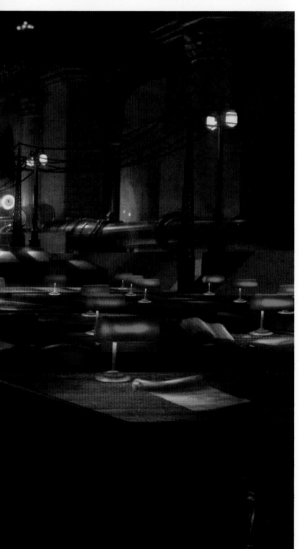

Surveillance
Monitors
Kurt Kaufman
September 2002
digital

he North Pole is where Christmas presents are made for good boys and girls; the downside is that Santa needs a surveillance system to track who's being naughty or nice. "The implication is there are tiny cameras in everyone's home," Chen smiled. "When you're naughty it alerts the surveillance camera."

Rick Carter described one of the major portals in the movie as the tunnel leading to Video Surveillance Control, the place where elves monitor the children of the world. "Video Control is a good example of 'method designing,'" Carter explained. "From a general idea, it got described as a big open hall like Grand Central Terminal, with these big stacks of monitors that tell whether kids are naughty or nice."

Ticker Tape Machine
Kurt Kaufman, September 2002
digital

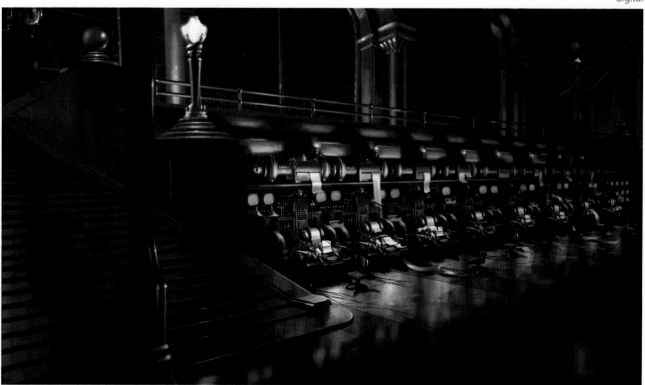

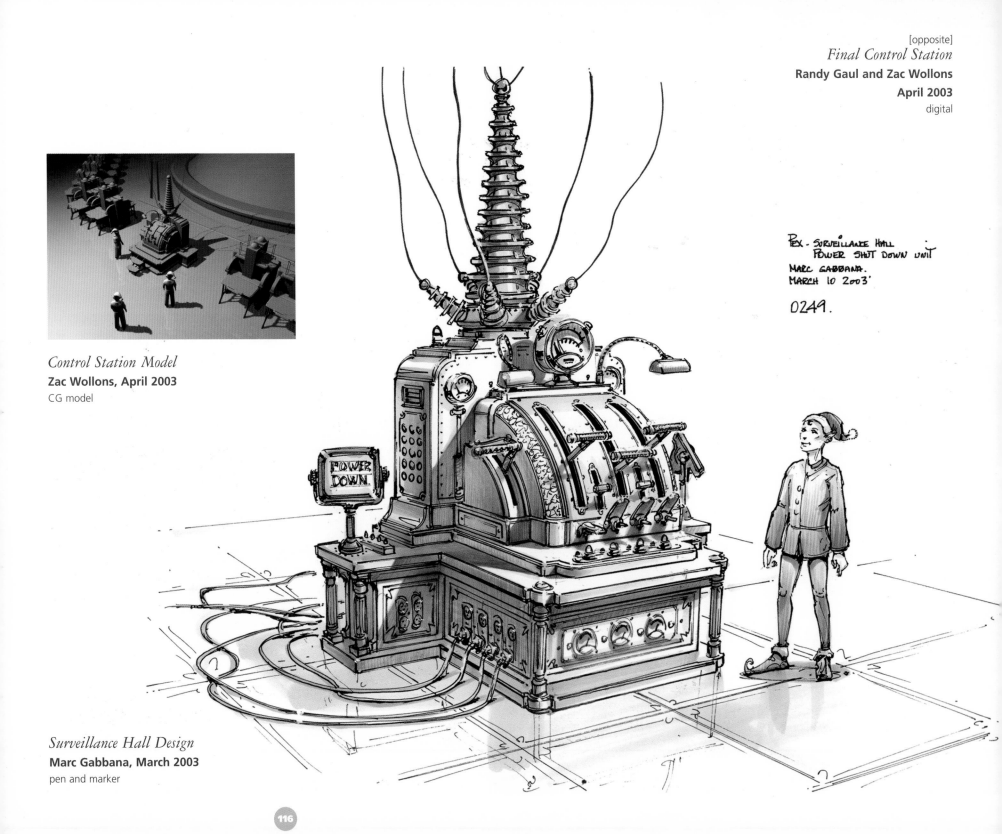

Final Control Station
Randy Gaul and Zac Wollons
April 2003
digital

Pex - Surveillance Hall
Power Shut Down Unit
Marc Gabbana.
March 10 2003

0249.

Control Station Model
Zac Wollons, April 2003
CG model

POWER
DOWN

Surveillance Hall Design
Marc Gabbana, March 2003
pen and marker

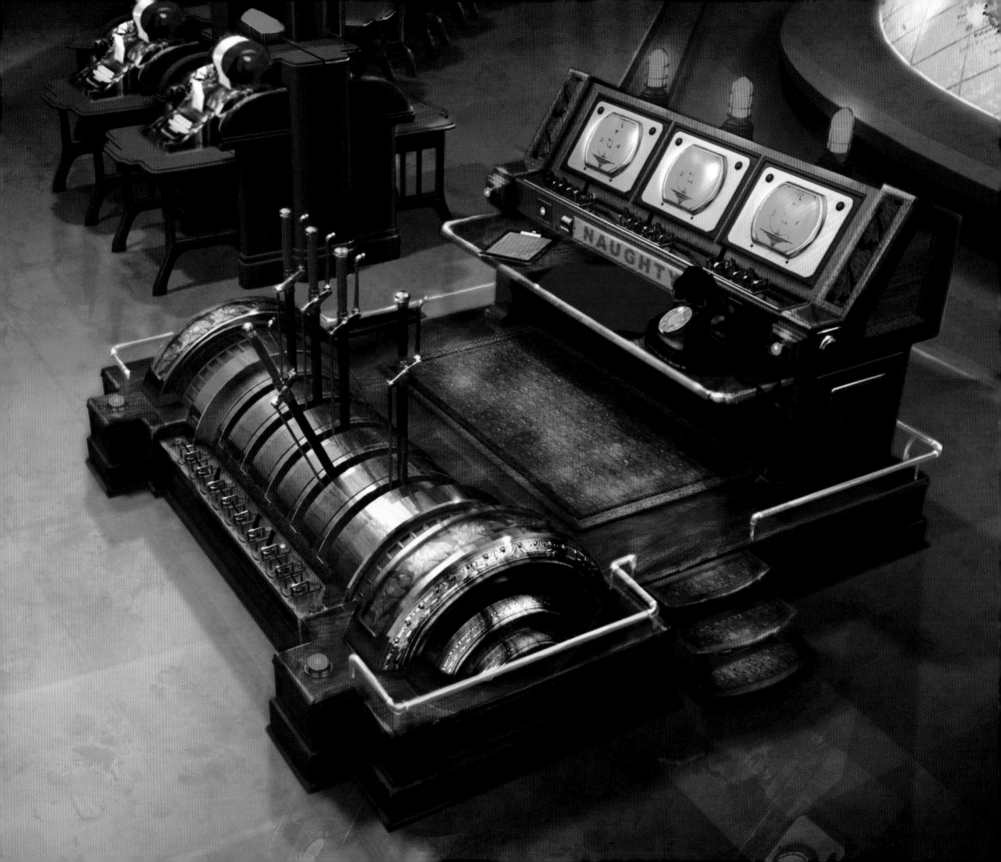

For me, the book took me distinctly into what I call the "waking space," that state of mind between sleeping and waking where you have a touchstone in reality but are still seeing through a dreamlike filter. When you're in that dream state you're vulnerable to a lot of emotions that kind of wash over you—and that's what I felt, like a ripple running through my body, as I read the book. I said to Bob, "This is a place worth transporting people to in cinema."

—**Steve Starkey**

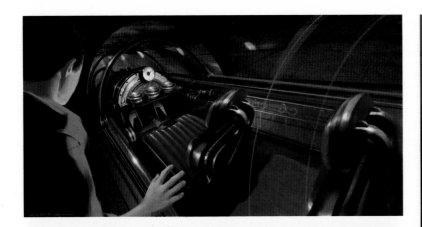

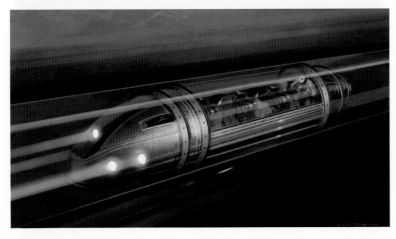

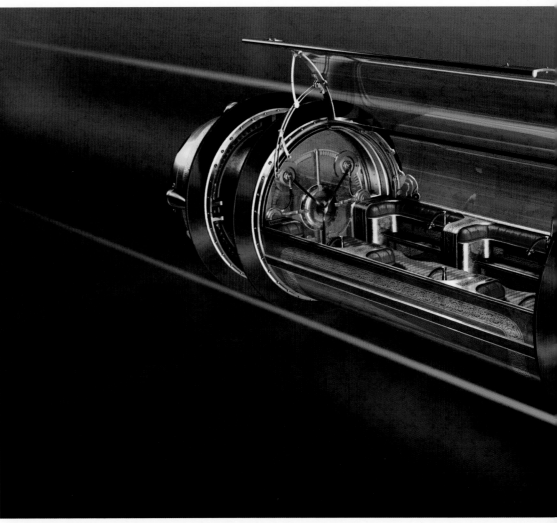

Early Tube Car Designs
Doug Chiang, June 2002
digital

Tube Car Station
Kurt Kaufman, September 2002
pen and marker

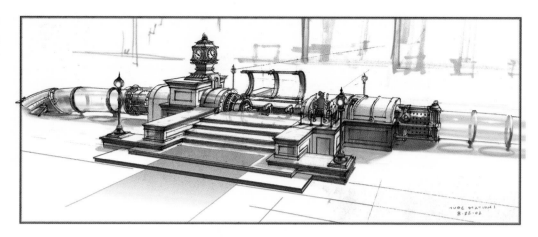

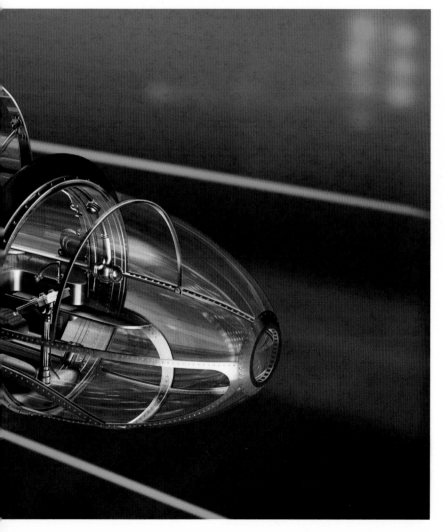

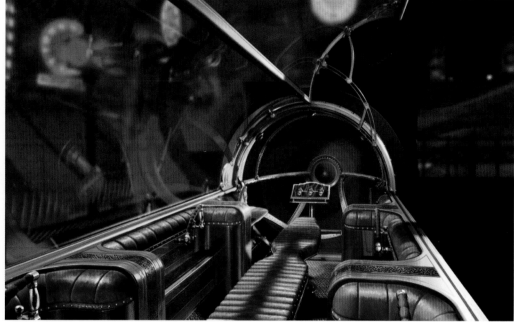

Final Tube Car
Kurt Kaufman and Pete Billington
February 2003
digital and CG model

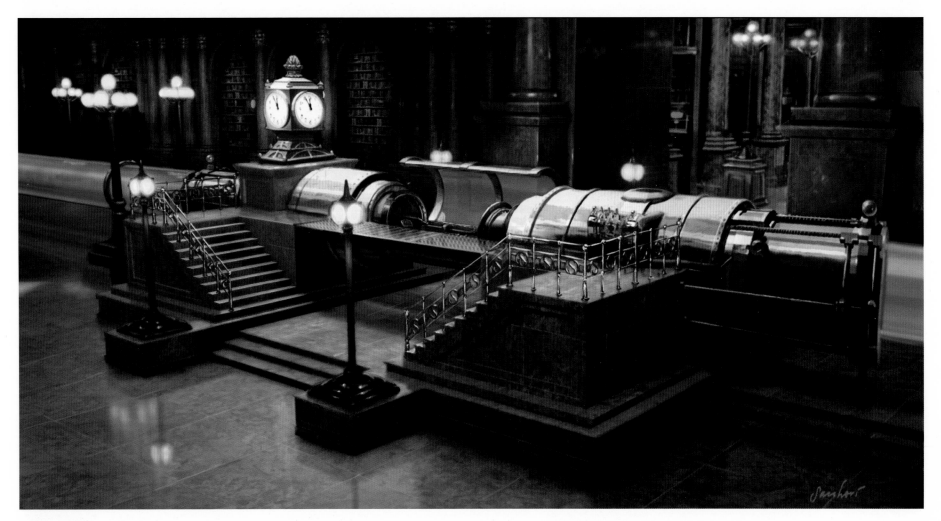

Final Tube Car Station
David Saccheri and Young Duk Cho
February 2003
digital

What I love about our visit to the North Pole is this sense, just like when the curtain is pulled back to reveal the Wizard of Oz, that we're getting a glimpse of a world that really works. The kids get into one of the pneumatic tubes the elves use to travel around the North Pole and it stops at Gift Wrap Hall, where all the presents for the world are wrapped. From there they go to the gift sorting room where Lonely Boy realizes the last Christmas present on the conveyor belt is his!

—**Rick Carter**

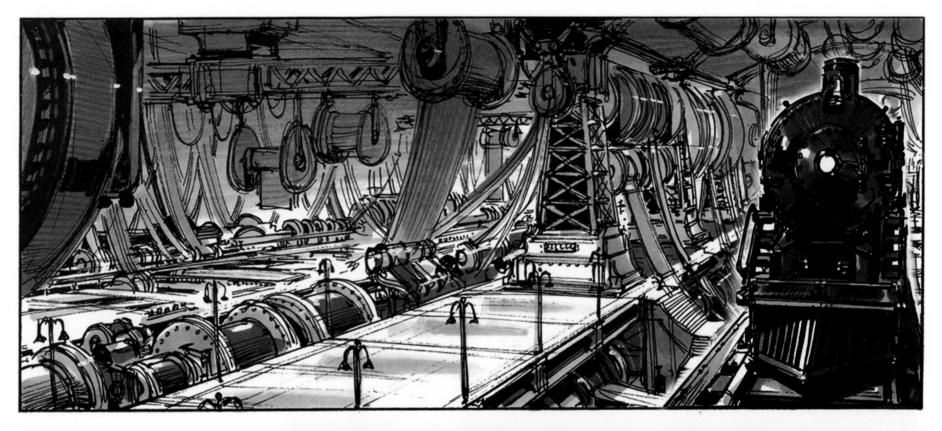

Preliminary Gift Wrap Hall
Marc Gabbana, September 2002
pen and marker

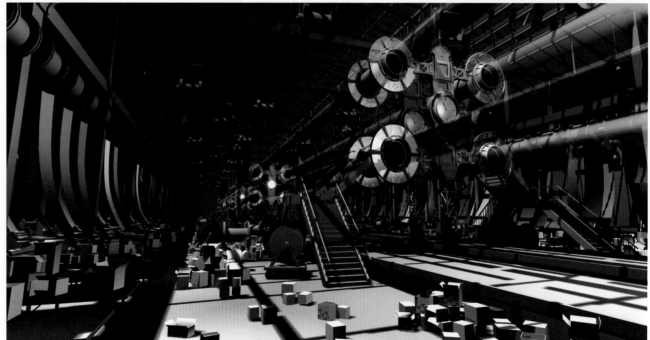

Gift Wrap Hall Concept
Young Duk Cho, November 2002
CG model

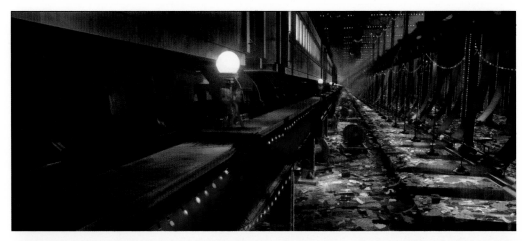

Gift Wrap Hall Concept
Mark Sullivan, October 2002
digital

[opposite]
Preliminary Sorting Room
Mark Sullivan, September 2002
digital

Final Gift Wrap Hall
Randy Gaul and Young Duk Cho
April 2003
digital and CG model

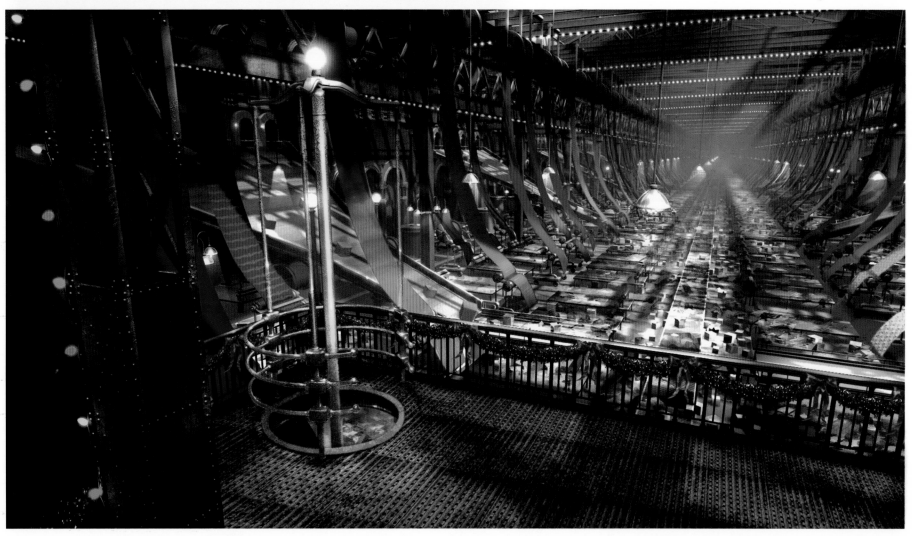

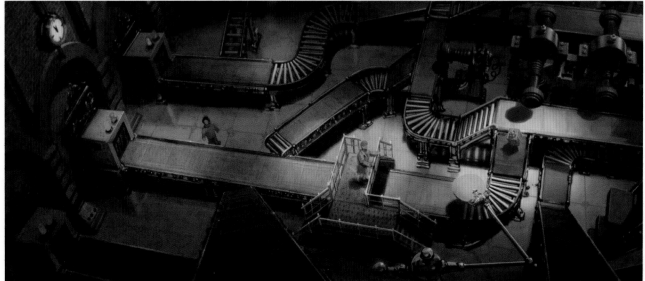

Sorting Room Concept
David Saccheri and Marc Gabbana
September 2002
digital

Sorting Room Concept
Bill Mather and Marc Gabbana
September 2002
digital

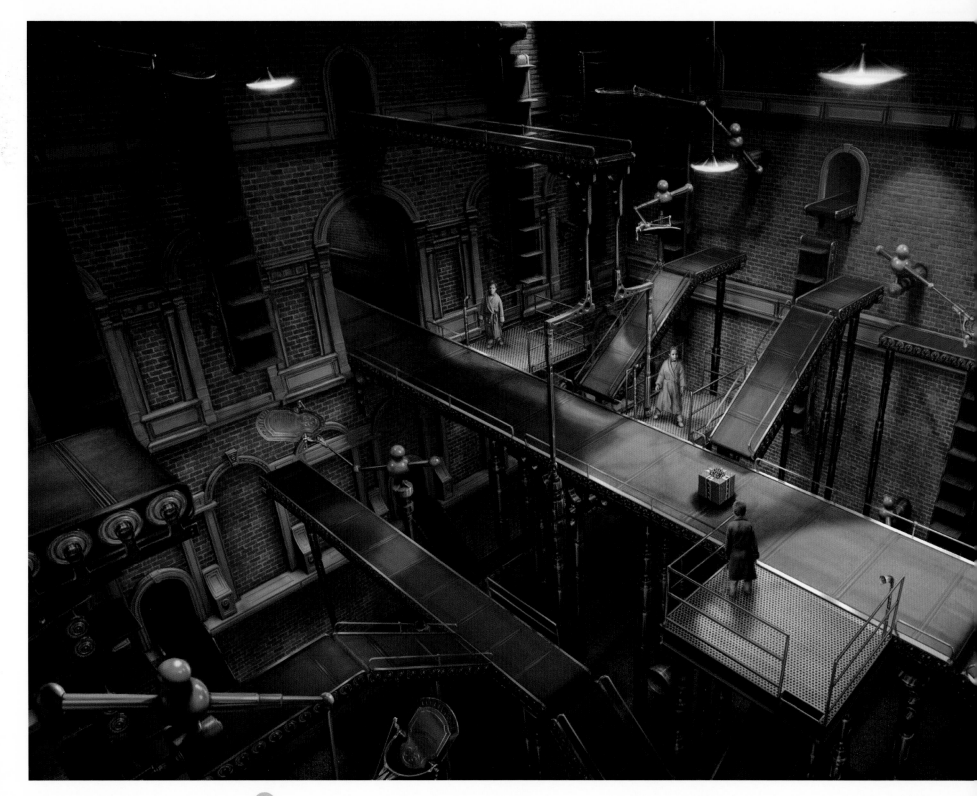

Funnel Room
Mark Sullivan
September 2002
digital

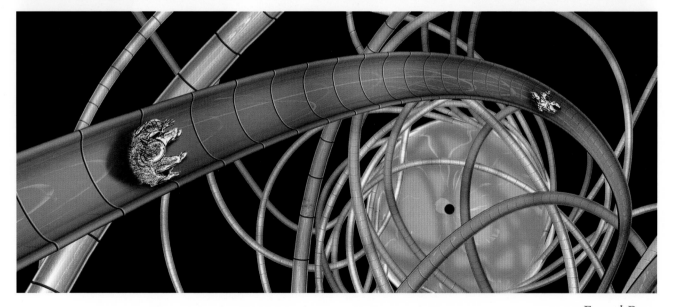

Funnel Room
Zac Wollons
September 2002
CG model

Final Sorting Room
David Saccheri and Zac Wollons
November 2002
digital and CG model

Present Crawler Designs
Marc Gabbana, August 2002
pen and marker

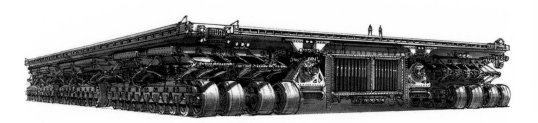

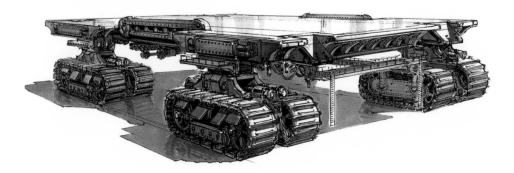

Early Present Room Design
Doug Chiang, June 2002
digital

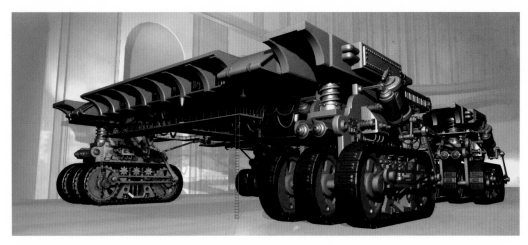

Present Crawler
Pete Billington, October 2002
CG model

The children then fall into a pile of gifts in this loosely draped sack, which is Santa's Christmas gift bag. It has rockets that shoot up into a zeppelin, which then flies over and drops the bag down into the Square. This came out of a simple drawing I did of a funnel going into a bag, like we've reached a bottleneck of toys that have to get into that bag. It was just to stimulate Bob's imagination to solve a creative problem—or as Bob likes to call it, "an insurmountable opportunity." The zeppelin and the bag was actually the culmination of how to get our characters back to the main group at the Square.

—**Rick Carter**

Present Room
Development
Randy Gaul
October 2002
digital

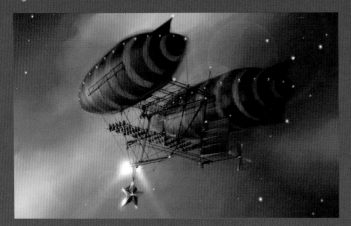

Early Zeppelin
Doug Chiang, April 2002
digital

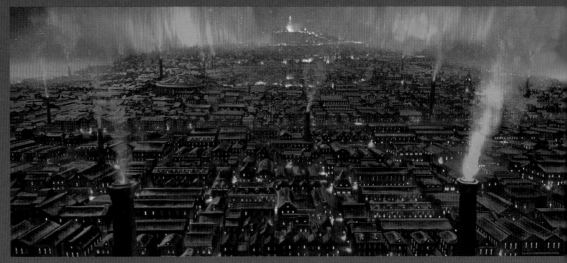

North Pole View
Mark Sullivan
December 2002
digital

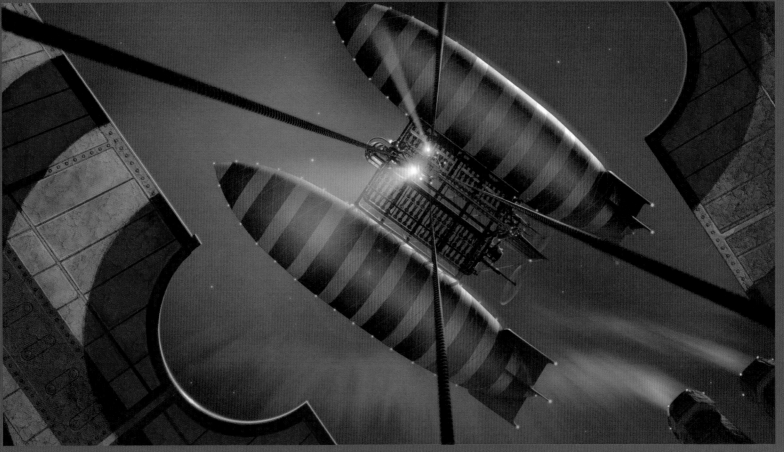

Final Zeppelin
Marc Gabbana and
Pete Billington
March 2004
digital

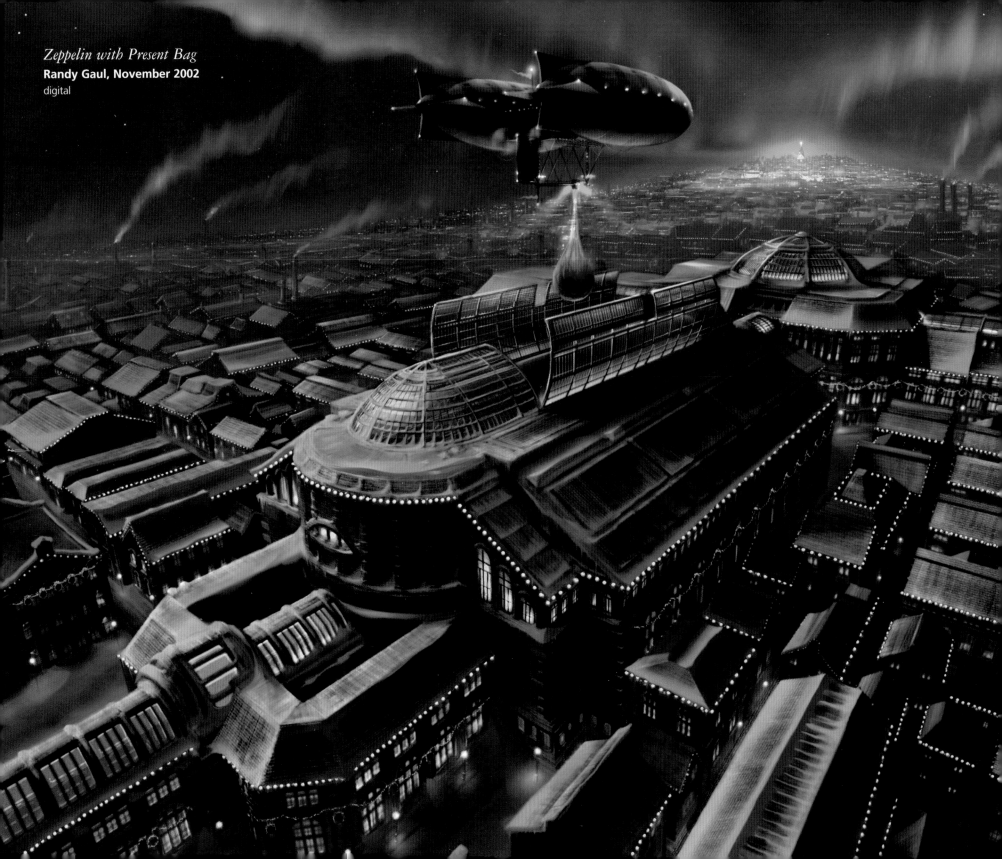

Zeppelin with Present Bag
Randy Gaul, November 2002
digital

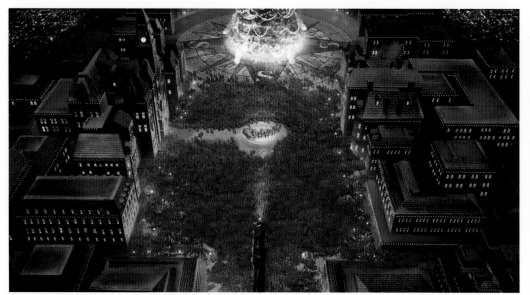

North Pole Square
Randy Gaul, November 2003
digital

It's been five minutes to twelve along the journey—when Santa appears the clock strikes midnight. The reindeer are excitedly kicking and cause one sleigh bell to fly off, and it lands at the foot of the hero Boy. He still can't hear anything—until he says, "I believe." And only then does the boy hear the bell.

—Rick Carter

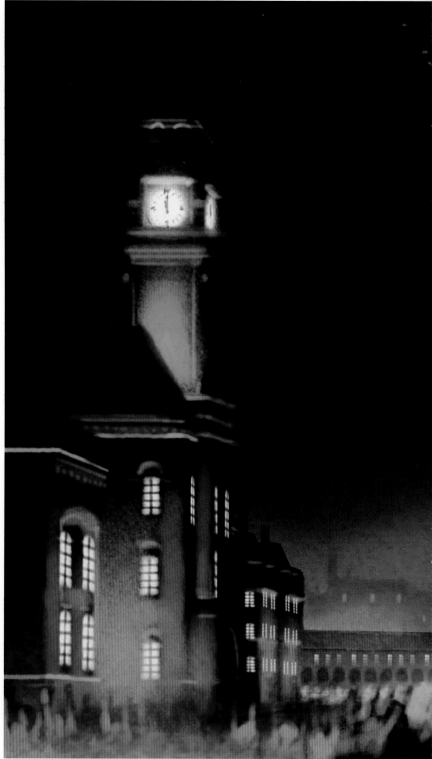

Early North Pole Square
James Clyne, December 2002
digital

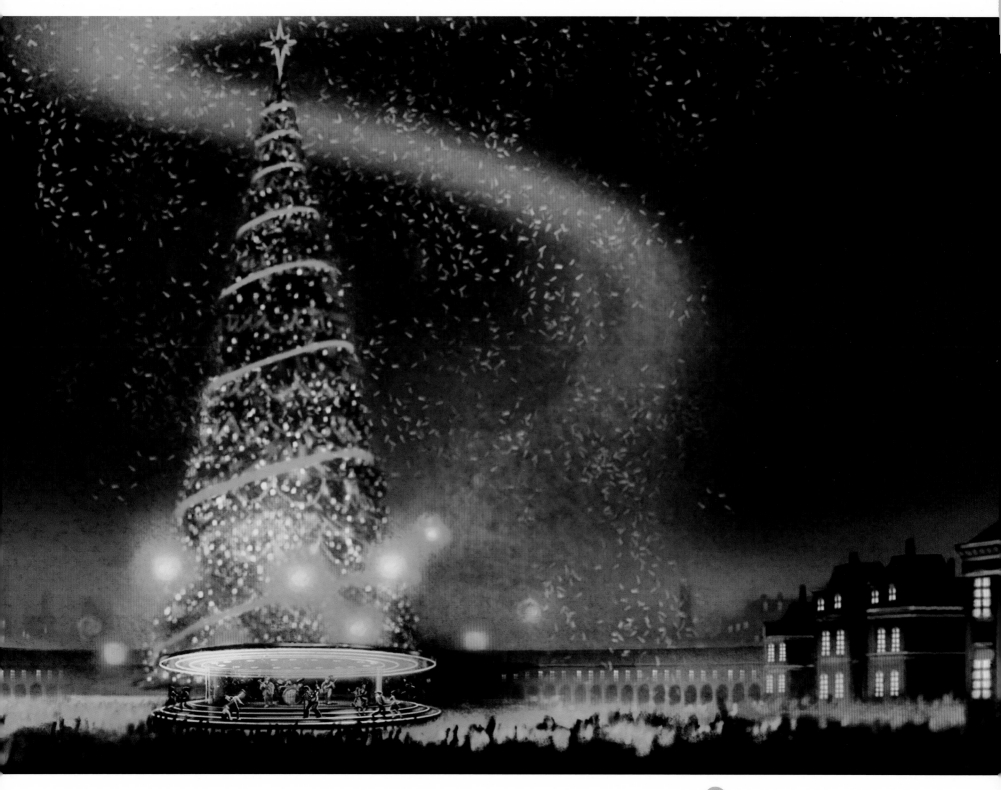

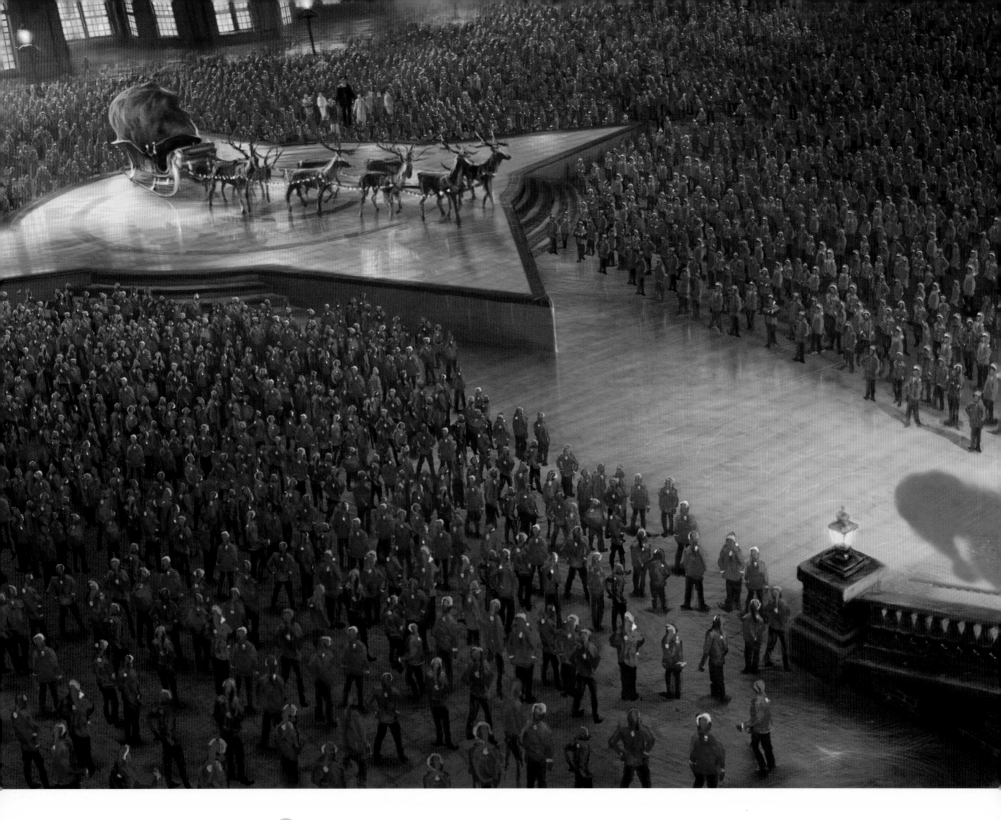

*North Pole Square
Development*
**Bill Mather and
Young Duk Cho
November 2002**
digital

*North Pole Square
Development*
**Randy Gaul and
Zac Wollons
November 2002**
digital and CG model

Santa's Shadow
**Mark Sullivan
February 2004**
digital

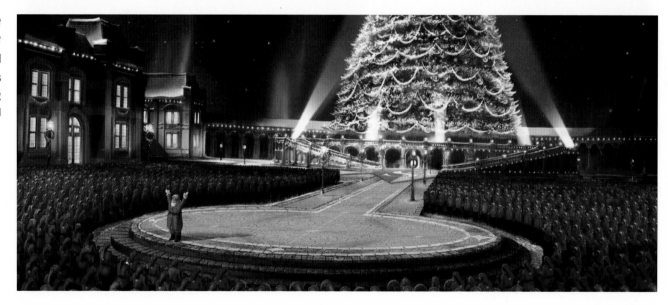

I wanted my portrayal of Santa to be perceived as a mix of both the caricature we've all grown up with and some genuine mystery. He doesn't "Ho, Ho, Ho" at the top of his lungs all the time although he does laugh, "Ho, Ho, Ho" to himself. Santa is aware of the power of his departing on Christmas Eve to deliver presents to the children of the world. Santa has been doing this for a thousand years and even he gets involved in the drama.

—Tom Hanks

I wanted a timeless, magical quality for Santa. His outfit is beautiful and rich, with the reds just vibrant, like a beacon. I also added an ethnic influence from the people of the Great North that can be seen in the craftwork, the beautiful embroidery of the suit. I also felt Santa's outfit should include a lucky talisman and I found an actual Siberian wood carving of a round disc with a wooden cross section. It's actually a calendar, a little lucky piece Santa wears on his belt buckle.

—**Joanna Johnston**

Santa's Sleigh
Randy Gaul and Young Duk Cho
December 2002
digital

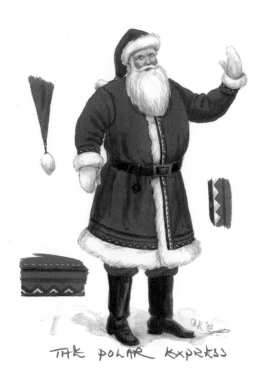

Santa's Costume
Robin Richesson
April 2003

Reindeer Designs
Marc Gabbana
February 2003
digital

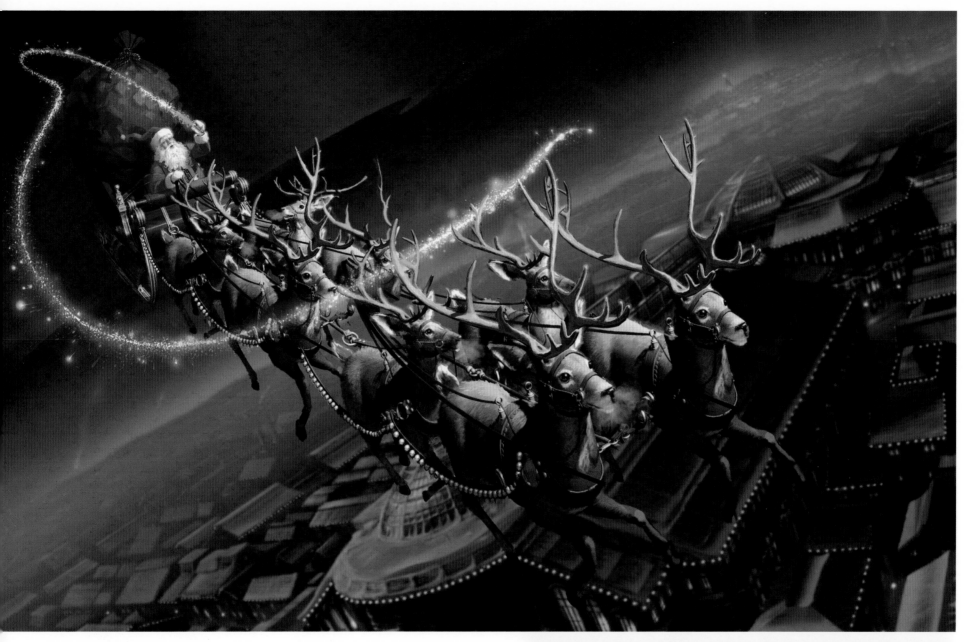

Santa's Whip
Randy Gaul and Bill Mather
February 2004
digital

Santa Dust
Kurt Kaufman
August 2003
digital

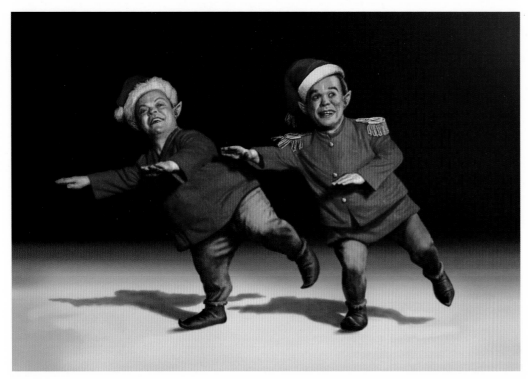

Elf Band
Randy Gaul, January 2004
digital

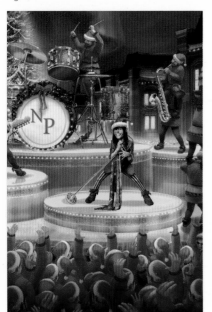

[above and below]
Elf Designs
Vladimir Todorov
April 2003
digital

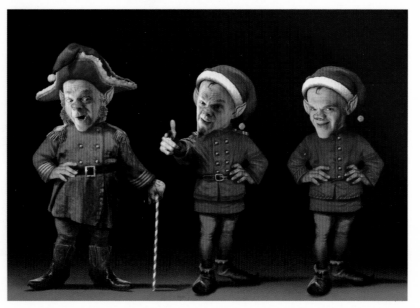

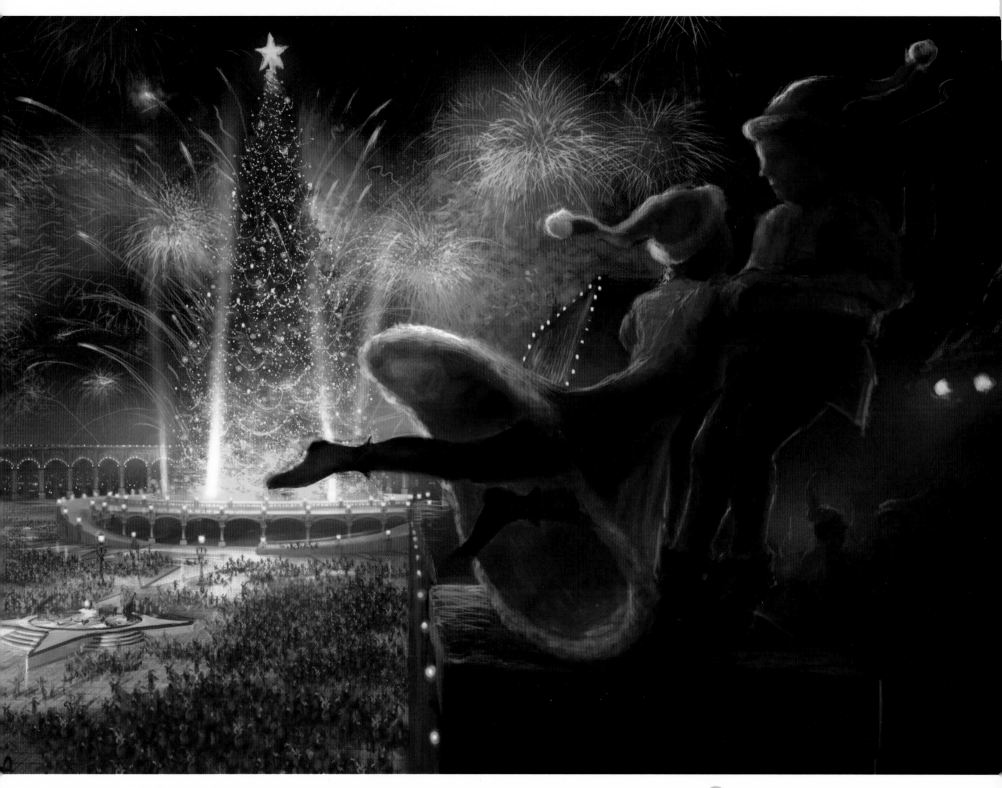

There's a great line in *Hamlet* that goes, "There are more things in heaven and earth than are dreamt of in your philosophy." That's a thought I hold dear. I want to believe that tomorrow I may discover something that turns everything I've known upside down and Santa and Christmas is that. I know in my heart Santa Claus doesn't exist—but wouldn't it be great if he did?

I can vicariously fulfill that wish and live it out by experiencing things like working on this movie and designing these fantastic worlds. I try to make them work and believable enough so if I was a kid I'd say, "Yeah, this is real."

—**Doug Chiang**

Elf Stage
Kurt Kaufman
February 2004
digital

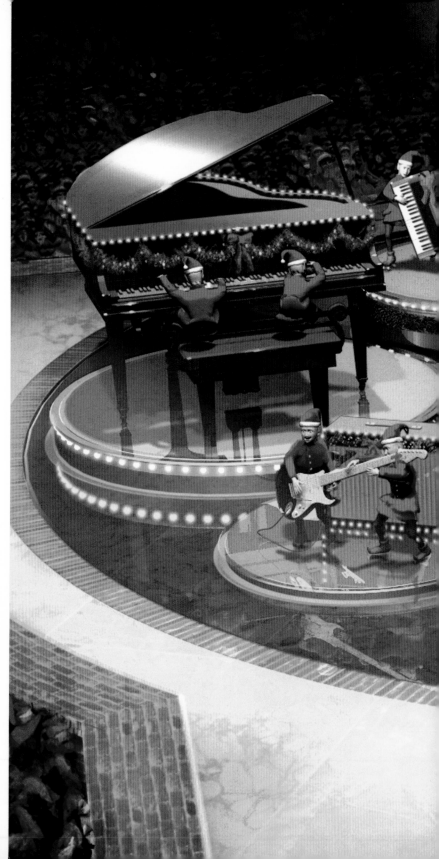

Steve Starkey poses with wireframe instruments used on the performance-capture stage for the big band sequence. The instruments were created overscale so that when played by a six-foot-tall human, both the performer and their instrument would scale down to elf-size.

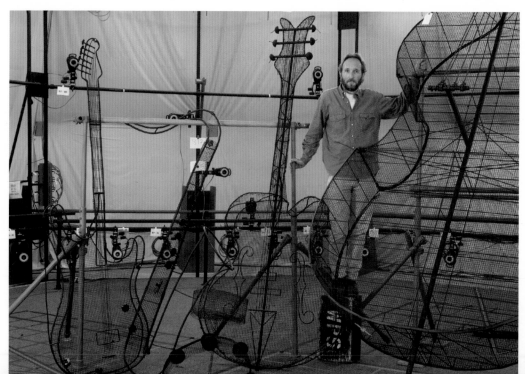

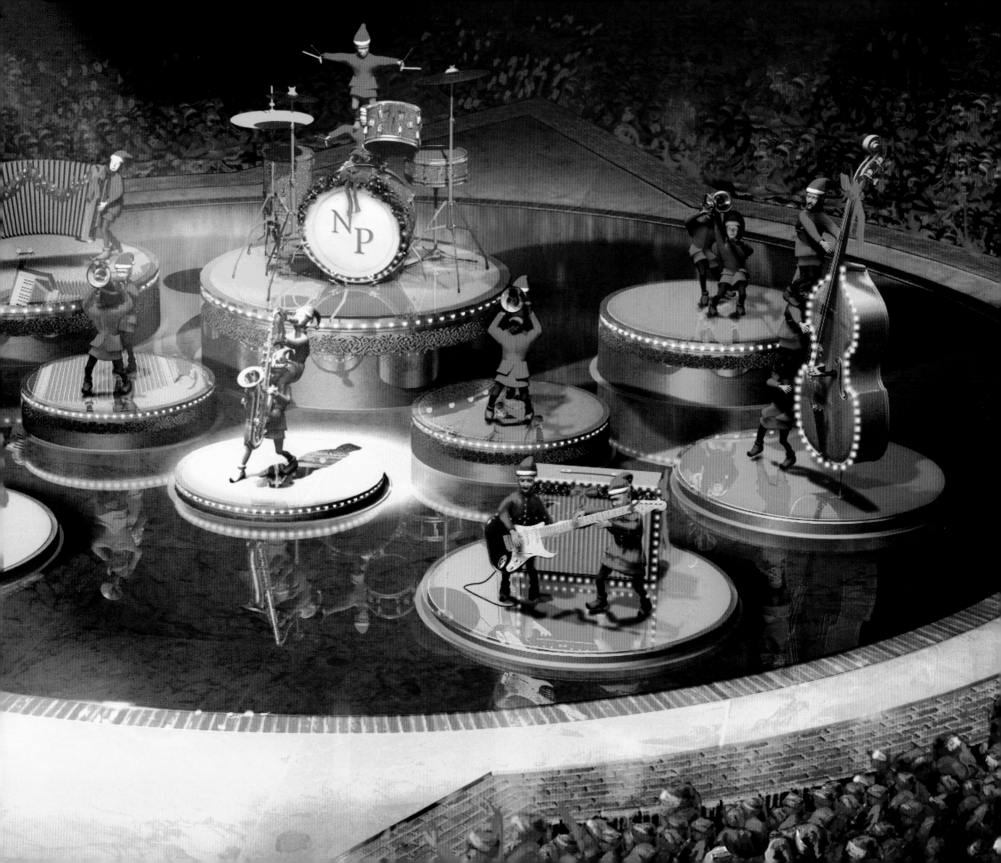

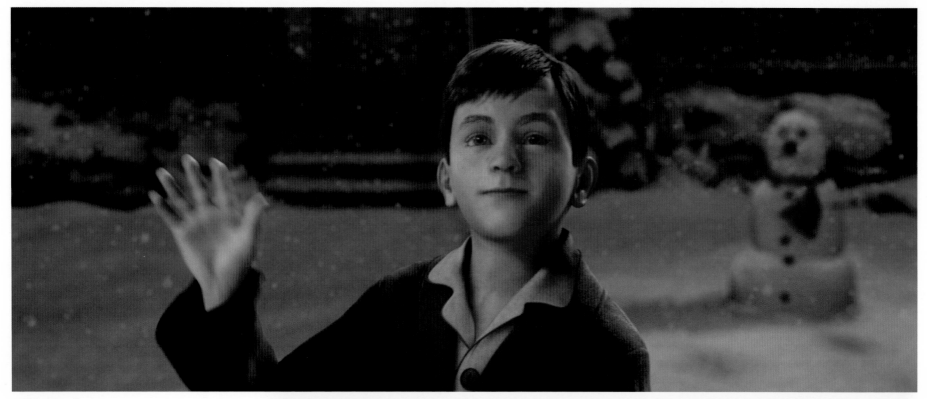

Film Final
Sony Pictures Imageworks

Wonderful thing about trains, it's good to know where they are going, but what really matters is deciding to get on.

—**The Conductor,** *The Polar Express*

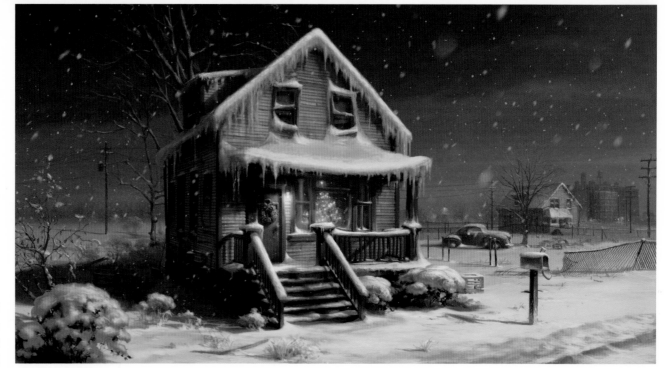

Lonely Happy House
Mark Sullivan
September 2003
digital

In order to become emotionally engaged in a movie, you have to come in and suspend your disbelief, that's inherent in what cinema is. So, you come out of the theater with a real feeling based on that experience—now what do you do about it? That private understanding and emotion is not dissimilar to the Boy losing his bell on the train trip back home. Did he see Santa? Yeah. Did he believe? Yes, he did. Can he convince anyone else he experienced these adventures? No! But the journey validated itself through the boy's own belief. It's like taking the Polar Express in our own lives, it's the belief system that works and sustains you, some faith in the unknown.

—**Steve Starkey**

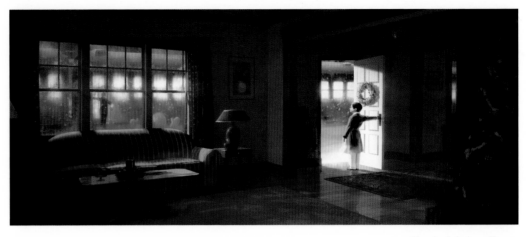

Boy's Living Room
Aaron Becker, January 2004
digital

Hobo Goodbye
Marc Gabbana, November 2003
digital

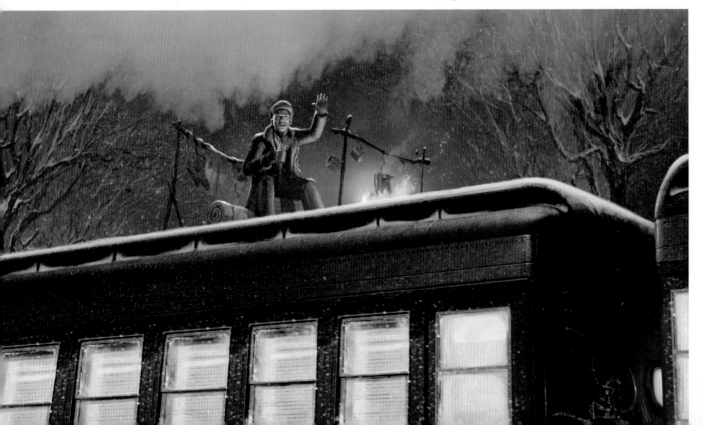

For some people, the news that there was never a Santa is the first bitter awakening that there are lies that are being told. I was maybe ten or eleven when I realized Santa wasn't real. I'd succeeded in fooling myself for years. But that really didn't matter—you could still choose to believe! You can believe in the *spirit* of it, which is more important than believing in the thing itself.

—**Jerome Chen**

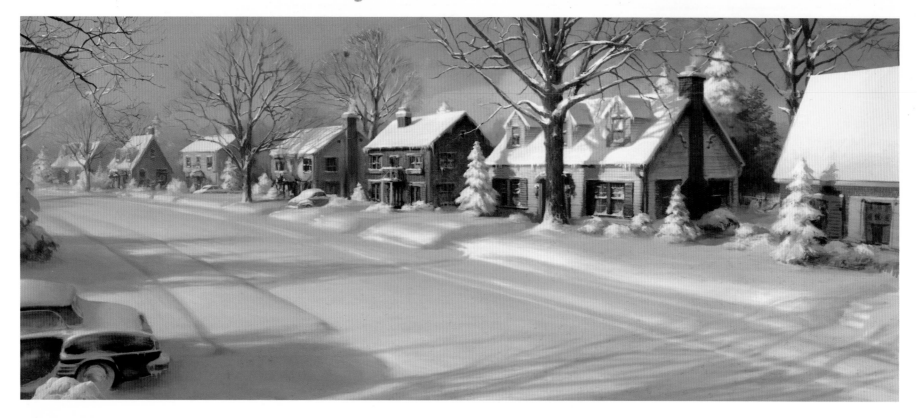

Christmas Morning
Mark Sullivan
September 2003
digital

oes Santa Claus exist? There once was a newspaper editorial addressed to a little girl named Virginia that said, yes, there is a Santa Claus. There's also a rare, 1823 eyewitness account of the legendary elf coming down a chimney to fill Christmas stockings and a description of his parting: *He sprang to his sleigh, to his team gave a whistle, And away they all flew like the down of a thistle.* In recent times, news organizations have filed Christmas Eve reports of Santa sightings or radar tracking picking up the flying sleigh (although such reports might be tongue-in-cheek). But not so much as a single, snowy white hair from the beard of the Big Man himself has ever been physically recovered—and maybe whether Santa does or doesn't exist is beside the point.

"In Van Allsburg's book, as the Boy and his friends grow older, his friends stop hearing the bell—that's really powerful stuff," Zemeckis mused. "Kids think of the magic of Christmas in terms of this fat man coming down a chimney but, hopefully, as you grow older you don't become so cynical you stop believing, because the idea of Christmas is about warmth and being unselfish. Santa is a symbol of that and you don't have to believe in Santa to still have that feeling."

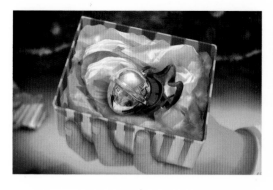 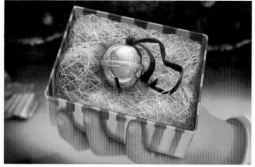 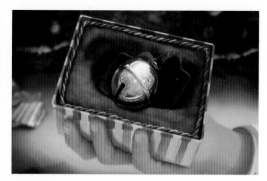

Bells
Randy Gaul
January 2004
digital

Visually, for the scene of Christmas morning, I was trying to get a feeling of what Christmas meant for me, what the morning felt like visually. Christmas for me was not being able to sleep the whole night and then as the sun came up seeing the way the light looked coming through the windows—that's what we were working with. I could smell the Christmas tree, if that's possible. We were trying to transfer those sensations onto the moving image to make this world both real and stylized, like painting on a canvas. You just go back to your childhood memories.

—**Ken Ralston**

Film Final
Sony Pictures Imageworks

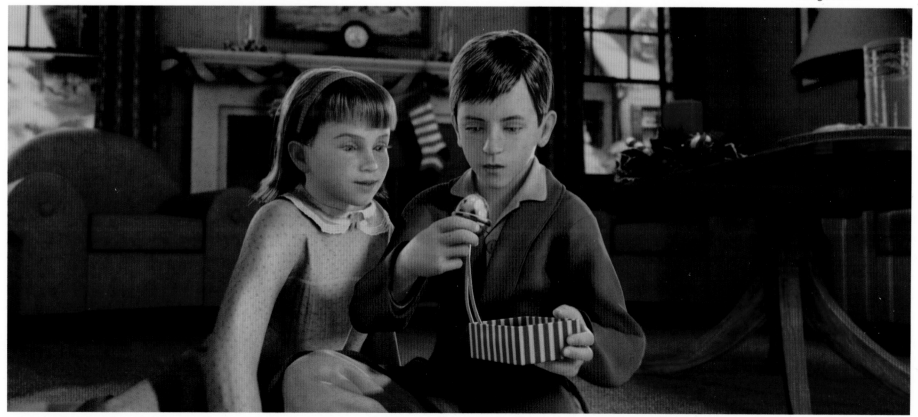

I guess whether or not you hear the bell is a matter of your own perspective. Reality is a constant, but everything depends on how you look at it. It all becomes very personal. That's why my favorite line I wrote for the movie is when the Conductor punches the kid's ticket and it spells out, "Believe." The kid starts to say, "Hey, my ticket…," and the Conductor says, "It's nothing I need to know." *It's nothing I need to know*. The idea is the message is for you alone.

—Robert Zemeckis

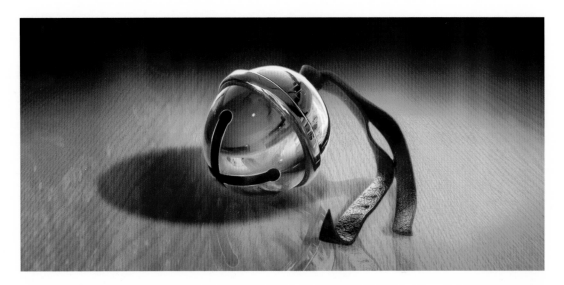

Bell
Kurt Kaufman
February 2004
digital